The Auction

MICHAEL JACKSON

by ARNO BANI

FOR FURTHER INFORMATION
+33 (0)1 49 49 90 11 or dblary@pba-auctions.com

RESERVATIONS
+33 (0)1 49 49 90 08 or ndubreuil@pba-auctions.com

ABSENTEE BIDS
+33 (0)1 49 49 90 25 or sgonnin@pba-auctions.com

PIERRE
BERGÉ
& ASSOCIÉS

ANTOINE GODEAU - FRÉDÉRIC CHAMBRE

AUCTION DATE
Monday, December 13, 2010 at 8 pm

AUCTION LOCATION
Hôtel Salomon de Rothschild
11, rue Berryer, 75008 Paris

EXHIBITION
Hôtel Salomon de Rothschild
11, rue Berryer, 75008 Paris
Saturday, December 11, 2010 from 10 am to 10 pm
Sunday, December 12, 2010 from 10 am to 10 pm
Monday, December 13, 2010 from 10 am to 3 pm

www.pba-auctions.com
www.pba-auctions-michaeljackson.com

12, rue Drouot, 75009 Paris **T.** +33 (0)1 49 49 90 00 **F.** +33 (0)1 49 49 90 01
Société de Ventes Volontaires_agrément n°2002-128 du 04.04.02

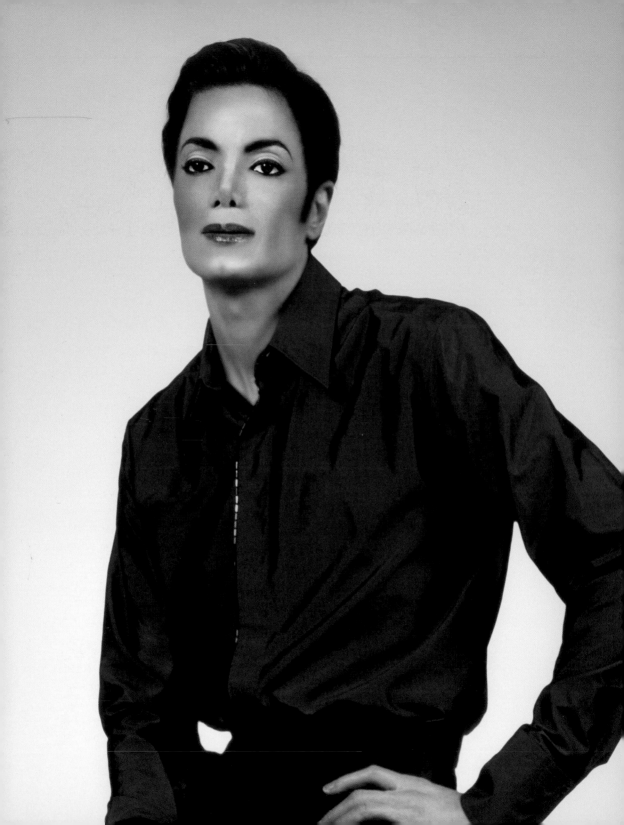

MICHAEL JACKSON
1958–2009

By Philippe Margotin

Gary, Indiana

From the moment that *I Want You Back* climbed to number 1 in the US Billboard chart and number 2 in the UK singles chart in January 1970, Gary, Indiana, was no longer simply the "Magic City of Steel." It was now famed as the home of the Jackson family. It was here on the edge of Lake Michigan, in the southeast suburbs of Chicago, that the five members of the Jackson Five were born: Jackie (Sigmund Esco) on May 4, 1951; Tito (Toriano Adaryll) on October 15, 1953; Jermaine on December 11, 1954; Marlon on March 12, 1957; and Michael on August 29, 1958. The Jackson family also included Maureen, born May 29, 1950; LaToya, born May 29, 1956; Randy, born October 31, 1961; and Janet, born May 16, 1966.

Under the very strict guidance of their father Joe, and with the support of Diana Ross, who had seen them perform on stage, the Jackson Five signed a contract with Berry Gordy's Motown label. The amazing adventure had begun. *I Want You Back* was followed by many outstanding hits, including *I'll Be There, ABC, Mama's Pearl, Never Can Say Goodbye,* and *Doctor, My Eyes.* At their concerts, The Jackson Five crossed all barriers of age and race, bringing the energy of rhythm 'n' blues and the warmth of soul music to huge audiences.

Michael goes solo

But Berry Gordy wanted to go further and let the five brothers record solo. It was Michael who got the ball rolling with *Got To Be There*, the single which eventually became the title track for his first solo album, released in 1972. On the album were Bill Withers's *Ain't No Sunshine* and Carole King's *You've Got A Friend*, as well as Leon Ware's *I Wanna Be Where You Are*, Leon René's *Rockin' Robin,* and *Love Is Here And Now You're Gone* from Motown's phenomenal songwriting team of Holland–Dozier–Holland. Michael's debut album shot to number 3 on Billboard's rhythm 'n' blues chart, and number 14 on the pop album chart, selling almost four million copies worldwide. For Berry Gordy and Michael Jackson, this was more than beginner's luck. A star was born.

While continuing to pursue his musical career with his brothers, Michael recorded several solo albums for Motown, all containing international hit singles. Initially released as a single, *Ben* later appeared as the title track on Jackson's second solo album (1972), and was Jackson's first number one as a solo artist. On *Music And Me* (1973), his third solo album, hits included the title track, *With A Child's Heart,* and *Happy* (the latter the theme from the film *Lady Sings The Blues* by Sidney J. Furie, starring Diana Ross in the role of jazz singer Billie Holliday). *Just A Little Bit Of You* was the big hit from his fourth solo album, *Forever, Michael* (1975).

In 1976 came the end of the relationship between the Jackson brothers and Berry Gordy. For the Jacksons (as they were now known), signing a new contract with Epic not only allowed the group to breathe new creativity into their music, but it was also an opportunity for Michael to let his inspiration run free. During the band's recording sessions for *Goin' Places* (1977) and *Destiny* (1978), he continued to work his own projects. He sang alongside Diana Ross in *The Wiz* (1978) by Sidney Lumet, a remake of *The Wizard of Oz*, and then with Quincy Jones as producer, he went into the studio to record his fifth solo album, *Off The Wall*, released in 1979. Songs included Paul McCartney's *Girlfriend* and Stevie Wonder's *I Can't Help It*, but it was Michael's own compositions that created the biggest buzz, including such classics as *Don't Stop Till You Get Enough*, *Rock With You*, and *She's Out Of My Life*. *Off The Wall* was a huge commercial success with 11 million albums sold. No African-American artist had ever before achieved this level of success.

Thriller and *Bad*

Earning him a Grammy, *Off The Wall* made Michael Jackson the new star of soul. But this was just the warm-up for what was to come. The follow-up album came in 1982, two years after the Jacksons' appropriately named album, *Triumph*, but also after the first revelations into Michael's personal life hit the media. Hormone injections to maintain his high voice, plastic surgery, and various treatments to preserve his "eternal youth"— incredible allegations of this kind were all over the papers.

The artist responded to the rumors with an absolute masterpiece, once again record-ing with Quincy Jones and Rod Temperton (British keyboardist of the group Heatwave). *Thriller* topped the charts with a string of consecutive hits: seven number ones, including *Billie Jean*, *The Girl Is Mine* (with Paul McCartney), and the title track. It was the perfect fusion of decades of popular music. *Thriller* was also groundbreaking in turning music videos into a new artform, mini-movies in themselves. (The *Thriller* video was directed by John Landis.) And of course, there was Michael's signature dance move, the moonwalk, showcased for the first time during a performance of *Billie Jean*, when Michael Jackson and Berry Gordy reunited for the 25th anniversary of Motown in May 1983. Even today, *Thriller* remains the best-selling album in the world, with 118 million copies sold.

Rather than lock himself up in an ivory tower as many artists would after such artistic and commercial success, Michael Jackson was ready to tackle new challenges. He teamed up with his brothers to record *Victory* (1984) and went on tour with them. He then played the title role in *Captain Eo*, a short 3D film directed by Francis Ford Coppola for Disney Parks. In 1985, together with Lionel Richie, he also composed *We Are The World* for USA for Africa, recorded by an impressive group of celebrities to raise money to fight against the famine in Ethiopia. Michael Jackson was now regarded as the "King of Pop," a fact symbolized by his purchase of the publishing company ATV Music, which owned the rights to two thirds of the songs of the Beatles.

But what most interested the public and the critics was his music. It was now 1987. *Thriller* was old news. So why such a long silence? Was the creator of *Beat It* and *Billie Jean* lacking inspiration? The release of *Bad*, on August 31, 1987 answered that ques-tion. The following figures speak for themselves: 11 songs (including nine written by Jackson himself), five number ones (the title track, *The Way You Make Me Feel*, *Man In The Mirror*, *I Just Can't Stop Loving You* with Siedah Garrett, and *Dirty Diana*), and 38 million copies sold. But perhaps most important, this third solo album with Epic marked a transformation, a new maturity that had not been seen before. The innocent young man had become the "bad boy." He was no longer just an teenager having fun, but a true artist, fully embracing his musical roots.

A moment of doubt

Michael's new musical direction was confirmed with the release of *Dangerous*, in stores November 26, 1991. With Teddy Riley succeeding Quincy Jones, this album was heavily influenced by the sounds of new jack swing. Yet it was the song with a rock influence, *Black or White* (with guitar from Slash of Guns 'n' Roses) that made waves, and reached the top spot in the charts on both sides of the Atlantic. The video, once again directed by John Landis, was another masterpiece, with the singer morphing into a black panther, making a strong symbolic statement.

Michael Jackson released two more albums, *HIStory: Past, Present And Future, Book I* (1995) and *Invincible* (2001), both following the work that had begun with *Bad*. The King of Pop shed his youth for good. On May 26, 1994, he married Lisa Marie Presley, daughter of Elvis and Priscilla. But two years later, Lisa Marie filed for divorce on the grounds of "irreconcilable differences." Only a few months after this, in November 1996, he married Debbie Rowe, his dermatologist's nurse. Together they had two children, Prince Michael Junior (born February 13, 1997) and Paris Michael (born April 3, 1998). An amicable divorce followed in April 1998. On February 24, 2002, he became the father of Prince Michael II (known as Blanket), born by artificial insemination.

Throughout his career, Michael Jackson took an active part in charity work, and in 1992 he set up the Heal The World Foundation to care for underprivileged children. But once again, rumors were rife, and then came the scandal. In March 1993, he was accused of child sexual abuse. He faced this same charge again in 2002. His home, Neverland Ranch, was immediately searched. An arrest warrant was issued, and Michael faced the possibility of twenty years in prison. The verdict came in June 13, 2005: he was found innocent on all counts. Michael Jackson was free. But the damage had already been done.

Four years passed. In March 2009, he announced a new series of concerts to take place in London—his very last, he assured everyone. This tour, with concerts scheduled between July and September of 2009, and then again in January and February of 2010, was entitled "This Is It." But on June 25, 2009, at his home in Bel Air, in the middle of the day, Michael lost consciousness and was rushed to the Ronald Reagan UCLA Medical Center. He passed away one hour later. The entire planet paid homage to him, while an investigation into his death immediately began. He was truly deserving of all his accolades. Performing for over four decades, Michael Jackson created music that encompassed the best of what music had to offer, and gave so many people a chance to dream.

1979 Off the Wall

1982 Thriller

1987 Bad

1991 Dangerous

1995 HIStory

—

2001 Invincible

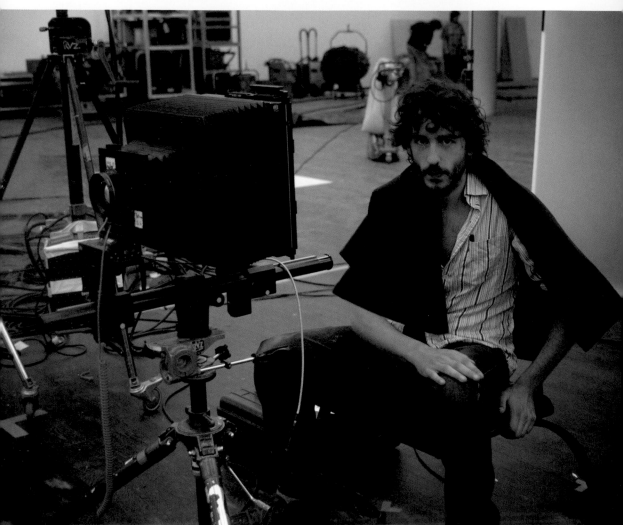

ARNO BANI
BORN 1976

Arno Bani's career began while he was still in high school. Self-taught and ambitious, he decided at the age of eighteen to take his first photographs as a means of visual self-expression.

Wanting to learn the craft from the inside and in a more professional manner, he left school and spent several months working as a floor assistant at some of Paris's best-known studios. But what he really wanted to do was go behind the lens himself. He took advantage of the facilities provided by the studios and made a push for the big time.

At the age of twenty, he took his first fashion and beauty shots in Sweden, and began to make a name for himself outside of Paris. He caught the eye of Isabella Blow, fashion director for London's *Sunday Times*, who saw his early work and spotted his talent. A relationship of mutual trust was formed, and they collaborated on many subsequent projects. The young Frenchman began to turn his camera to a wider range of subjects and his confidence continued to grow. His work reflected a mixture of thought and instinct, with redefined concepts of luxury and chic at the forefront.

Uniting his artistic talents and tastes with those of Ora-ïto and Topolino, Arno Bani went off the beaten path of fashion to create his own visual world and express his own particular vision of the female form.

Michael Jackson chanced upon Bani's work in the fashion pages of *The Sunday Times*, and commissioned the photographer to capture his image in a series of portraits. At the age of just twenty-three, Arno Bani found himself face to face with a living legend.

This collaboration sealed Arno Bani's reputation as one of the most talented photographers of his generation. He then received commissions from fashion houses and luxury brands such as Lacroix, Givenchy, and Cartier, and from musicians like David Guetta, Bob Sinclar, and the band Air. By the age of twenty-five, Bani was a photographer whose fame had spread beyond the fashion world. Bringing opposites together and blending classicism and modernity, his monochromatic approach to imagemaking could soon be seen everywhere. His work appeared in the pages of *Citizen K*, *Spoon*, *Visionaire*, and *Jalouse*, and he photographed Monica Bellucci, Mélanie Thierry, and Noémie Lenoir.

While his early work was marked by Red-Black and Puzzle symbolism, Arno Bani's later portraits began to focus on hyperrealism and what he calls "hypermatter." This transition was accompanied by the use of new printing and photographic techniques. In 2003, the Nicolas Hulot Foundation chose him to produce an advertising campaign, which was subsequently awarded second place in the photography category by the Club des Directeurs Artistiques.

Early in 2004, Arno Bani made his first film, the video for *Rocking Music* by French DJ and producer Martin Solveig. This led him to shoot his first commercial for the fragrance Hugo Boss Deep Red, starring Anouk Lepère, as well as a Club Internet ad campaign in early 2005.

In the summer of 2005, the talented art buyer Isabelle Baud chose Bani to produce the film and photo campaign for the opening of the new Modern Art Museum in Val-de-Marne (MAC/VAL). Using the motto "*Venez prendre l'art*" ("A breath of fresh art"), he took the conventions of modern art and projected them into his own creative world, stressing the richness of the colors and materials and giving them a more human dimension. The film won silver at Eurobest Live 2005, the European awards for creative excellence.

In early 2006, Arno Bani directed the video for *Happy Therapy* by Demon, starring Ora-ïto and Vahina Giocante, which was made to promote the first antidepressant perfume, Smiley. In this film, he experimented with 3D graphics, creating a spinning Rubik's Cube of images. Bani was also in charge of shooting the Smiley perfume campaign. Later that same year, he created a highly successful print campaign for TPS, using a series of heavily made-up eyes to promote the launch of a high-definition TV service. He then directed a memorable video for the song *Butterfly* by Superbus, in which the band and their instruments are gradually covered in glitter.

Also in 2006, Arno's work for MAC/VAL won him another honour, this time being chosen to appear in the prestigious D&AD annual. He was not yet thirty years old.

Opposite: Inside page of the Sunday Times Style supplement, April 11, 1999. Arno Bani

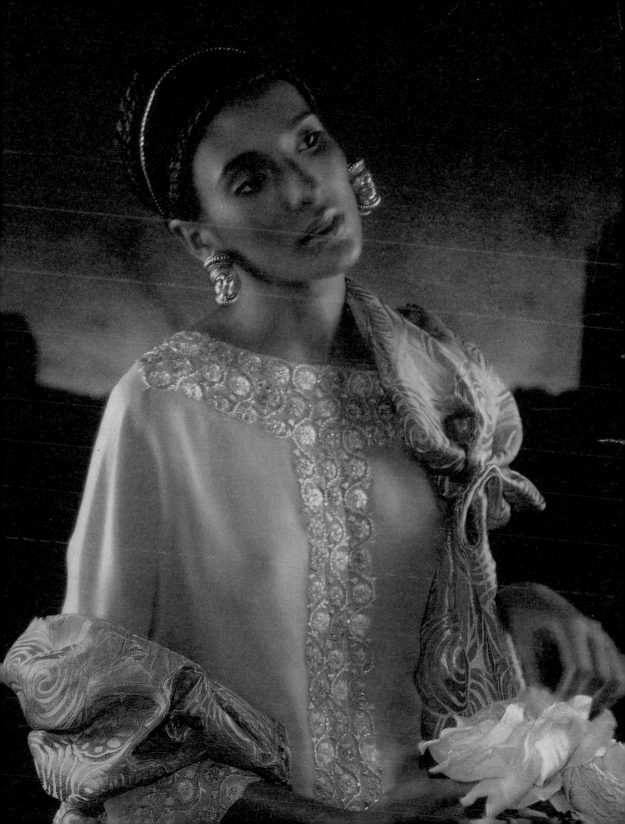

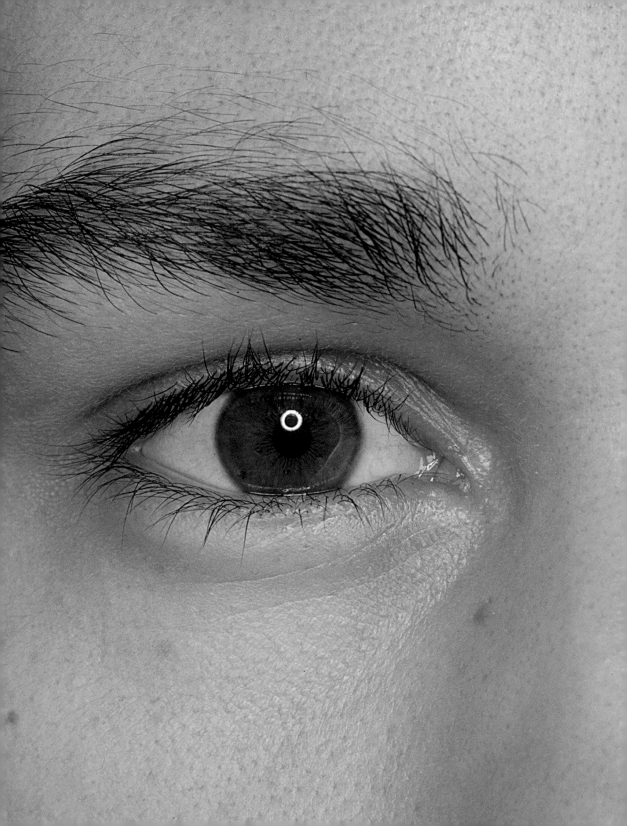

In 2007, Bani created an advertising campaign and sales catalog for a new high-end jewelry brand, Akillis. The brand offered "an ultramodern view, combining boldness and freedom of style," and the photographs reflected this youthful and innovative spirit. In the same year, Jérôme Coste commissioned Bani to shoot print ads for Les Ateliers Ruby, his prestigious brand of motorcycle helmets, taking an artistic approach that brought sport and aesthetics together. Throughout this period, Bani continued to work with friends including the young French designer Ora-ïto, and the actress Mélanie Thierry, whose portrait he shot.

Contemporary artists in the film, fashion and music industries looked to Bani to capture their images. He was invited to work with Frédéric Beigbeder, Xavier Veilhan, Jean-Charles de Castelbajac, Irina Volkonskii, the music group Air, and the art collective Kolkoz, whose work aims to reshape the world and make anything possible through a constant and dynamic rebuilding process.

In 2009, Awdio.com, a website that allows people to listen to live music worldwide, approached Bani to shoot photographs for a web campaign. In 2010, at a peak of creativity and success, Bani signed with the brand Samsung and shot a series of ads.

These few years have been more than enough for Arno Bani to prove himself as an independent artist whose talent is now internationally recognized and who is able to fulfill a wide range of briefs without compromising his own visual style.

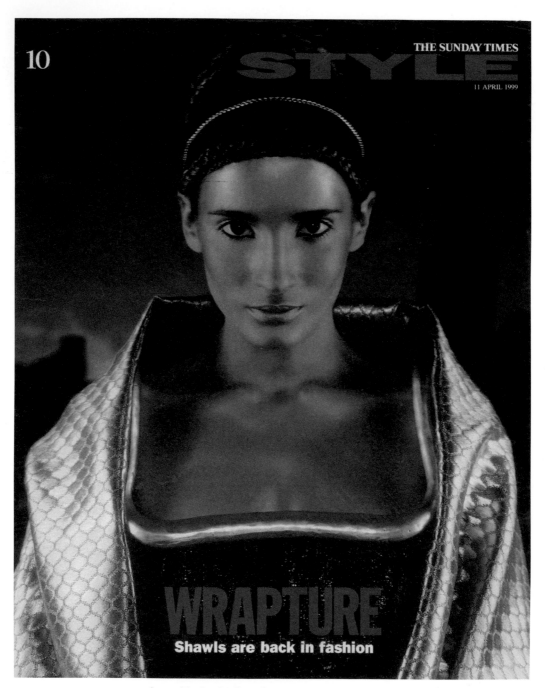

Cover of the Sunday Times Style supplement, April 11, 1999

ONCE UPON A TIME...
MICHAEL JACKSON
A SHINING STAR

By Jéromine Savignon

Forever Michael by Arno Bani

Once upon a time, in the land of music and moonwalking, in the land of all dreamers, there was a famous star, an unhappy clown who, more than anything, did not want to grow up. And so he sought to evade the march of time by disguising his fear behind glittering clothes, lightning-fast dance moves, and beautiful songs.

One day, in April of 1999, he found himself alone in a palatial London hotel suite. Alone, save for the cruel and overwhelming thoughts of his childhood, stolen away by a controlling father who wanted to make his five sons into superstars, no matter what the cost. The bad memories came flooding back: the iron hand of his father; the punishing schedule with day after day eaten up by concerts and rehearsals, with no time for childish playfulness and games; his early success as the youngest of the Jackson Five; then becoming a star, going solo and getting caught up inside the gilded cage of fame. On that morning, he was assailed by doubts. Away from the joyous catharsis of performance, the overwhelming exhilaration of music and dance, was he always destined to suffer the pain of being a child prodigy, cut off from the rest of the world? For once, just once, could he be free from the desire to run away and escape the torment of never being comfortable with himself, and the endless pressures of producing hit after hit? And under the many disguises and the glittering public mask, where was the real Michael? Michael, the kid with a voice like cut glass, the boy with fever in his feet and so much sadness in his heart.

On that day, April 11, 1999, in the anonymous and sterile luxury of a hotel room that could have been anywhere, Michael Jackson daydreamed and tried to forget his anguish and boredom. He was leafing through *The Sunday Times* as a distraction when suddenly the cover of the *Style* supplement caught his eye. The image was magnificent. Against the hazy background of an imaginary city, the model Astrid Muñoz stood framed by the metallic neckline of a Jean-Paul Gaultier dress, fit for a science-fiction princess, with an Indian shawl wrapped around her like a golden shell. Totally covered in iridescent silver makeup, her smooth face radiated an androgynous beauty; a beauty that was calm, impenetrable and yet exposed, like a retro-futuristic revival of the mystique of Byzantine icons. To Michael, the chance discovery of this image was not only an aesthetic pleasure but felt like finding a new escape route into a storybook world, a fairytale of the kind that had always helped him to survive. This unexpected occurrence felt like something that might save him from the shadows of his destiny, a kind of extraordinary talisman that could exorcize his sorrows. It appeared to be a light in the darkness, and all the more promising because it seemed to emanate a sense of dark fantasy similar to his own.

Michael Jackson was certain of one thing: he needed to meet the creator of this bewitching image. He soon learned that it was Arno Bani, a young Parisian fashion photographer, barely twenty-three years old. Bani was self-taught, extremely talented, and had been recently discovered by London's aristocratic style priestess, Isabella Blow, then fashion editor of *The Sunday Times*. She had first met Bani one evening at the studio of one of her protégés, the stylist Jérôme Dreyfuss, who was a friend of Bani's and his partner in all sorts of adventures and projects. Enchanted by Bani's hyperactive side, his boyish and rebellious dress sense, and his unbridled and poetic approach to creativity, Isabella Blow had already been working with him for several months.

As impatient as a child who's been promised a new toy, Michael instructed his closest retinue to invite Arno to New York with his lookbook. But the barrage of telephone calls was in vain. Arno couldn't believe what he was hearing and thought someone must be playing a trick on him. Michael Jackson wanted to see *him*? Surely not! It took the persuasive talents of his lawyer, Emmanuel Asmar, and a plane ticket to New York to convince Arno that this was not a dream. A day and a half later, Arno was in New York.

Arno couldn't believe what he was hearing and thought someone must be playing a trick on him. Michael Jackson wanted to see *him*? Surely not!

"Mr. Jackson will see you now." Down a secret hallway, a door opened at last and the star, in silk slippers and satin pajamas, reached out to embrace Arno. It was surreal.

Now the fairytale truly began: a limousine and bodyguards, a huge suite with a private billiard room at the Waldorf Astoria, and an introductory lunch with the staff of Michael's record company for a fast lesson in the etiquette of the court of the King of Pop. The final message was clear: "You're going to meet Michael this afternoon. From now on, forget everything, or else..." The warning was punctuated by an unambiguous gesture and an unmistakable sound effect. The suspense went on. A succession of rooms, walkie-talkies, and security men with empty stares, long minutes of waiting, and even a full search before the magic words were heard: "Mr. Jackson will see you now." Down a secret hallway, a door opened at last and the star, in silk slippers and satin pajamas, reached out to embrace Arno. It was surreal.

The meeting was truly magical. Together, Michael and Arno became playmates and partners in crime, ready to have fun. Lying on the floor, they explored Arno's lookbook, dwelling on the image from the *Sunday Times* for a long time. Leafing through the pages, Michael enthusiastically asked questions and occasionally lingered over an image he particularly liked before applauding softly, slowly, and with utter delight, and whispering in a soft and dreamy voice: "I like it... I like it..." The ever-present crowd of his assistants, manager, and art director, waiting silently in the back of the room, feverishly took a note of every photograph he liked. And here ended the ceremony, the first strange scene in what was to become the amazing story of Michael and Arno.

Shortly afterward, Michael let Arno know that he wanted to work with him. It must be Arno, whose youthfulness he had instantly felt, Arno and no other, who would create the cover artwork of his next album, in the style of the phantasmagorical image from the *Sunday Times*. He also asked Arno to think about other proposals, other looks, other scenarios for future projects; he wanted Arno's penetrating gaze to be inspired by him and to create an extravaganza of images fit for the 21st century.

Arno returned home from New York with tons of video cassettes, music videos, and mini discs, feeling like a dream had come true. He listened to *You Are Not Alone* over and over again, losing himself in the world of mindblowing concerts, screaming fans, and collective euphoria. This total immersion in an alien world—exaggerated, double-edged, and never before experienced—provided a glimpse into the tragedy, isolation, and loneliness that lay at the heart of Michael Jackson's life of make-believe; the sorrow and pain behind his iconic status.

After this intimate glimpse behind the layers of artifice and legend, Arno, the magical photographer of the invisible, decided that what he most wanted was to show the Prince of Pop's face, his features, the truth of a lost childhood, and to capture this heartbreaking beauty forever. He could already see a parade of images as they flashed in 3D before his mind's eye. Michael's hair would have to be cut short; everything would have to be based around a look, a style, glittering with light.

First Arno put his team together, a gang as young and crazy as himself, all huge fans of Michael and all thrilled by this incredible project. A vow of complete silence was imposed, virtually turning the group into a kind of mystical sect, dedicated to the cult of "MJ." There was Jérôme Dreyfuss, the stylist, with his muse Frédérique Lorca who acted as his assistant, the stylist Maïda, the hairdresser Seb Bascle, the makeup artist Topolino, a poetic painter of faces, the talented set designer Daniel Adric, and of course Arno's assistant, Gilles Quemoun. They were buzzing with energy, ideas were coming together, and rough sketches were taking shape. They trawled luxury boutiques and press offices, searched for ideas for sets and fabrics, and collected embroidery samples from the House of Lesage. There were impromptu brainstorming sessions in which, just for fun, liberties were taken with the record company's marketing rules. The secrecy was so intense that Michael Jackson's measurements were sent from New York in the most storybook circumstances: in a diplomatic-style attaché case, hand-delivered by a special courier to Arno's Parisian lawyer.

The chemistry between Arno and Michael continued to grow: faxes, telephone calls in the middle of the night, lightning-fast trips to New York. Working in symbiosis, they spent two months in unforgettable collaboration, in a haze of playful euphoria. Theirs was a perfect balance of give and take. Michael was endlessly bewitched by Arno's talented and intuitive eye and enthralled with everything he brought to the table. He loved stroking the fabrics, joyfully digging his hands into the jars of glitter and blowing on them to watch the colors fly. A moment later, he could be passionately taking to Arno about one of his idols, Fred Astaire.

Working in
symbiosis,
they spent
two months
in unforgettable
collaboration,
in a haze of
playful euphoria.

Michael wholly
and unconditionally
allowed Arno's
inspired eye and
camera to capture
his image nearly
four hundred times.

To Arno's amazement, Michael loved and agreed to everything, and the photographer soon understood that this apparent suspension of all criticism was highly significant: "He loved everything, not because I was always right, but because all he wanted was for us to go ahead with the photo shoot no matter what the cost, for there to be a variety of sets, props, costumes, and makeup designs, and for us to have fun with all of it." More than just a cover image for his next album, what Michael wanted from this chosen brother figure, who had flown into his kingdom like Peter Pan, was for him to keep turning dreams into reality, again and again, making them bigger and better every time.

The photo shoot was scheduled to take place at the beginning of July, in Paris and amid the greatest secrecy, and became the lasting record of a magical meeting in which dreams were the stars and anything was possible. With the trust of a child, the discipline of a dancer, and the powerful need to keep going further, Michael wholly and unconditionally allowed Arno's inspired eye and camera to capture his image nearly four hundred times, all in pursuit of one photograph to illustrate each of the four main themes they had selected during their collaborative craziness.

The adventure began at the Hôtel Plaza Athénée, on the eve of the big day, with a fitting session in Michael's private apartments. As always, Michael was delightful, playful, sensitive, and endearing. The next morning, Arno's entire team met in a huge movie studio in Issy-les-Moulineaux, specially hired and fitted out in accordance with a Hollywood-style list of specifications. It also included a lavish playroom for Prince Michael, Michael's eldest son. In a matter of seconds, the high metallic hangar doors could be closed to conceal "MJ," his limousine, and his suite, and everything was done to ensure the utmost privacy and luxury. Reserved exclusively for Michael's personal use, a pathway of soft carpet led from his car to his trailer, and from his trailer to the sets, where a series of studios had been installed, with their own lighting and props, allowing him to move quickly from one set to the next. Everything was ready to welcome the prince.

Arno's team, their average age only twenty-five, got ready in a haze of excitement, like a class of schoolchildren without a teacher. The team waited for their idol, but the prince didn't show. To stave off their growing impatience, everyone kept busy. Arno focused on his film stocks, carrying out more tests; one more time, the set decorator watered the bed of roses that resembled something from *Alice in Wonderland* or *The Wizard of Oz;* the stylists, hairdressers, and makeup artists played like children with the luxury gadgets in this extraordinary place, reminiscent of the TV show *Big Brother*. At around one o'clock in the afternoon, the energy faltered. "MJ" had not arrived; there was no news and anything could have happened. For Arno and his team, anxiety reached a peak when they discovered during lunch that Jackson's entire staff—the record company entourage, costume and makeup people—were there, giving everyone orders. The warm atmosphere grew cold and the day ended on a gloomy note.

The following morning, morale was at its lowest. And then, suddenly, the news spread by walkie-talkie: "The Authority," Michael Jackson's code name, was on his way; he was somewhere on Paris's outer ring road, trying to thwart fans and paparazzi. This news was greeted with a mixture of relief, curiosity, and impatience; everyone manned their battle stations. A bodyguard pushed everyone behind the safety of a huge black curtain, designed to protect Michael as much as possible from prying eyes.

At last, he appeared. Arno greeted him. The ceremony of the photo shoot could begin.

The image for the *Invincible* album cover opened the proceedings. With complete artistic freedom, the photographer approached the session with his usual energy, a subtle mix of professionalism and flashes of sudden, inspired improvisation. "I wanted it to be beautiful, elegant, and right, and timeless too. I couldn't surround Michael with anything too complicated, a crazy and pretentious set where he would have been lost. I just wanted to show off the best in him but stay respectful, to get back to basics with 'nothing.' 'Nothing,' a word I love. 'Nothing' as the keynote for hair, makeup, styling, unsophisticated lighting, no special effects. To do something pictorial, something graphic, something pure, using simple elements of elevated reality."

Arno's team,
their average age
only twenty-five,
got ready in a haze
of excitement, like a
class of schoolchildren
without a teacher.
The team waited for
their idol, but the
prince didn't show.

"Daddy, you look great!" exclaimed Jackson Junior enthusiastically at each one of his father's metamorphoses. And Michael smiled.

Michael seemed worn out, exhausted, as if filled with a great emptiness, and so frail that you wanted to take him into your arms to protect him. But under this touching fragility lay incredible charisma, strength, and a unique sense of authority. His ability to concentrate surprised everyone on the set. During a makeup session, he could stay impassive for hours, silently staring at the mirror, letting everyone get on with their allotted task. But, much to his chaperones' displeasure, he could also go wild with Arno and his friends over an old French song from the seventies, coming from Topolino's cheap radio. Nonetheless, he still bore the demeanor of a tragic hero. His son, Prince Michael, never very far away, seemed to be the only one who could break through the veil of restraint that seemed to clothe him: "Daddy, you look great!" exclaimed Jackson Junior enthusiastically at each one of his father's metamorphoses. And Michael smiled, reassured for a while. But when he caught a glimpse in the mirror of his son misbehaving, he frowned and Prince Michael had no choice but to obey.

Extremely focused and precise, the star did everything that the photographer asked of him, willingly and with the utmost kindness. Under his personal hairdresser's disapproving gaze, he was given a drastic haircut, which he loved. It was just his style to resist the intolerable pressures put upon him by the amorphous mass of his entourage, and make a desperate attempt to shake free from a whole system, old-fashioned, demonic, and devouring, that was supposedly there to protect him and his own star status but which had become a malaise that was smothering and stifling him.

Once the styling was done and the lighting was right, Arno liked to shoot quickly, in a high-risk improvisational style, giving few directions, and Michael played along perfectly. Their chemistry was intense. So much so that, when they were on the set with the white backdrop and Mozart's Requiem filling the studio, Arno picked up his Polaroid for the first test shots, then did a few dance steps and said: "Move a little, move from right to left." Before he could even finish his sentence, something happened that he had never expected: Michael Jackson did a few moonwalk steps for Arno alone, while looking him straight in the eye. Overwhelmed by the almost surreal nature of this private show, Arno shot a series of images without thought or hesitation, then threw aside his Polaroid and grabbed his Pentax. Time was flying by....

At the end of the final day, in beautiful weather, Michael took his leave, speaking to Arno with hands pressed together, as if reciting a soft litany: *"Thank you very much, thank you so much, thank you, thank you...."*

In front of the closed doors of the Issy-les-Moulineaux studio, bouquets and notes had already been solemnly left by fans, in spite of the secrecy surrounding the shoot. Arno's team, their heads still in the clouds and their thoughts still with Michael, suddenly felt empty and lost, yet they had the gratifying feeling of having managed to restore an inner truth to the King of Pop. Like a declaration of love, the team had given him a glimpse of normal life, the pure, unexpected joy of not being lonely at the top, if only for the time it took for a shutter to click and a bulb to flash.

Michael Jackson, almost since birth, had been immersed and imprisoned in the illusory world of celebrity and its run-of-the-mill fairytales. He was also a child of the American dream of the 1950s, but to him, America was a paradox: both the richest and the unhappiest country in the world, where success promised much, but brought nothing but endless monotony, existential melancholy, and sentimental nostalgia.

When Michael began his solo career, Quincy Jones gave him a unique opportunity. The producer broke open Michael's cocoon, revealing to a fascinated world an unprecedented hybrid of funk, soul, rock, and pop, whose jagged and contradictory edges melded into an ever-changing musical mixture, international, unpretentious, explosive, and ridiculously beautiful.

The infernal machinery of the record industry and the Jackson clan soon crushed this moment of grace and truth without a second thought. Everyone had simply thought they were agreeing to an inconsequential whim by tolerating Michael's sudden interest in Arno. But the actual stakes were much higher; this was "for real." By deciding to place his image into Arno's hands, fearlessly and unconditionally, Michael Jackson had unconsciously rediscovered the beauty of his work with Quincy Jones. And just like in *You Rock My World*, one of the first tracks from *Invincible* that Michael had let Arno hear on that night in New York, Arno had no idea of the truth behind the lyrics: "Life will never be the same."

Arno had no idea of the truth behind the lyrics: "Life will never be the same."

From all the contact sheets that Arno submitted, marked with his own comments and preferences, Michael chose four images. Finally, after retouching and final approval, it was time for the prints' final journey across the Atlantic. Like a burst of spontaneous, childlike applause—just the kind that Michael was known for—the definitive versions embody the complicity and collaborative spirit that brought the images into being. Four unique and unforgettable portraits of the world's biggest and brightest star, all by Arno Bani:

Michael Jackson's Blue Eye: A sad clown; the fragility of a lost little bird already on his way toward the wonders of Neverland. Vibrant yet impassive, childlike innocence and unrevealed dramas lie hidden behind the intense and artificial blue of a closed eye. A perfectly arched eyebrow, the strong, graphic look of the short hair, the sharply defined collar. An almost sacred stillness strips away the drama and emphasizes the mirror embroidery that covers the Yves Saint Laurent tuxedo jacket with sparkling rays of light. Clean and precise, the truth of a myth is captured in a fleeting moment, like a memento mori. As Shakespeare wrote, "Grace is grace, despite of all controversy."

Michael Jackson with Red Background: The most touching and perhaps the most captivating of portraits: the singer stands dreaming, unguarded, reflective and solemn, waiting for the stage lights to go out. Uncertainty? Relief? Loneliness? Perhaps there's a little of all these things in the fragile and fluid ambiguity of a dark, androgynous silhouette, clothed in the silk of a Yves Saint Laurent shirt.

Michael Jackson with the Golden Cape: The image of a boy king or a young god, enveloped in a soft halo of glowing light, like the dawn or the sunset. He seems to reign over the earth, impassive, enigmatic, and bare beneath a heavy cloak of gold. Beneath the smooth fringe of short hair lie dark eyes that could have come from an Egyptian portrait, clear and timeless, gazing out but never seeing. Truly invincible.

Michael Jackson with the Silver Hand: Silver hand on his heart, a young man in a mask becomes an otherworldly being, a fugitive from a faraway galaxy that has left him sprinkled with stardust, and where he dreams of returning one day. Like Howard Hughes, he creates worlds and shoots through the skies at lightning speed. His eyes are all that can be seen, childlike and gentle, always seeking the unreachable star.

Michael Jackson, clothed in light:
four faces in four photographs,
each one unique, long hidden away
in the secrecy of a safe, and now
uncovered for the first time.

With dazzling sophistication, timeless and yet fleeting, Arno Bani manages to give each one of these portraits depth, brilliance, character, and presence, combined with the strong, graphic modernity of contemporary fashion photography. "I am a photographic designer," he likes to say.

Michael Jackson was overwhelmed by the results, and tracked Arno down by telephone, finally reaching him on vacation in the mountains, to thank him over and over again. And then there was silence, a very long silence.

The album *Invincible* was released in 2001 but it was not one of Arno's images that adorned the cover. Arno and Michael had been betrayed.

Michael Jackson, clothed in light: four faces in four photographs, each one unique, long hidden away in the secrecy of a safe, and now uncovered for the first time.

Once upon a time, there was an incredible encounter between a young photographer who could move easily between dreams and reality, and a sad and lonely clown who did not want to grow up.

A true story that sounds like a fairytale.

Let's dance

AUCTION
NO RESERVE PRICE

The magical discovery of these exceptional portraits of Michael Jackson, taken by Arno Bani, raised one very important question:

What estimate could be set for these images?
€500, €1,000, €10,000, €50,000, €100,000, €200,000...?

Seasoned collectors and amateurs alike will be able to determine the value of these prints for themselves.

We have therefore decided only to set a starting price:
For the four large prints: €1,000
For the 6 x 7 prints and contact sheets: €500

Let's dance!

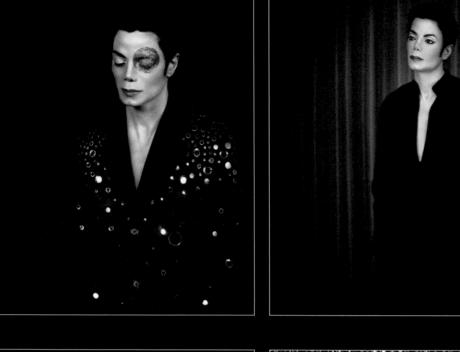

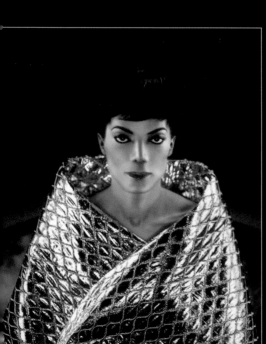

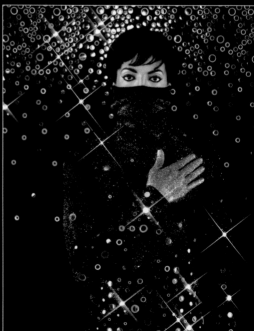

THE SELECTION

BY MICHAEL JACKSON

From all the contact sheets that Arno submitted, marked with his own comments and preferences,

Michael chose four images.

Four unique and unforgettable portraits of the world's biggest and brightest star.

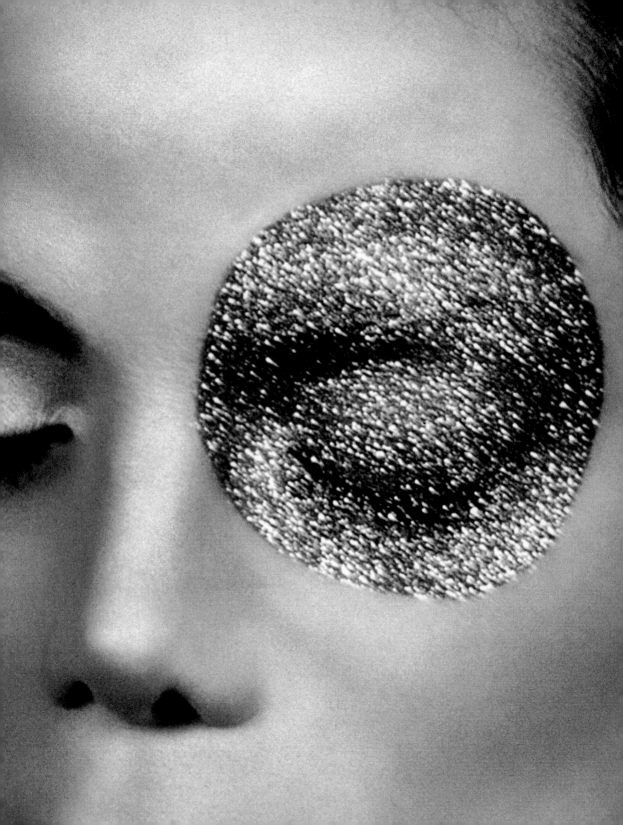

MICHAEL JACKSON'S
BLUE EYE

Vibrant yet impassive, childlike innocence and unrevealed dramas lie hidden behind the intense and artificial blue of a closed eye.

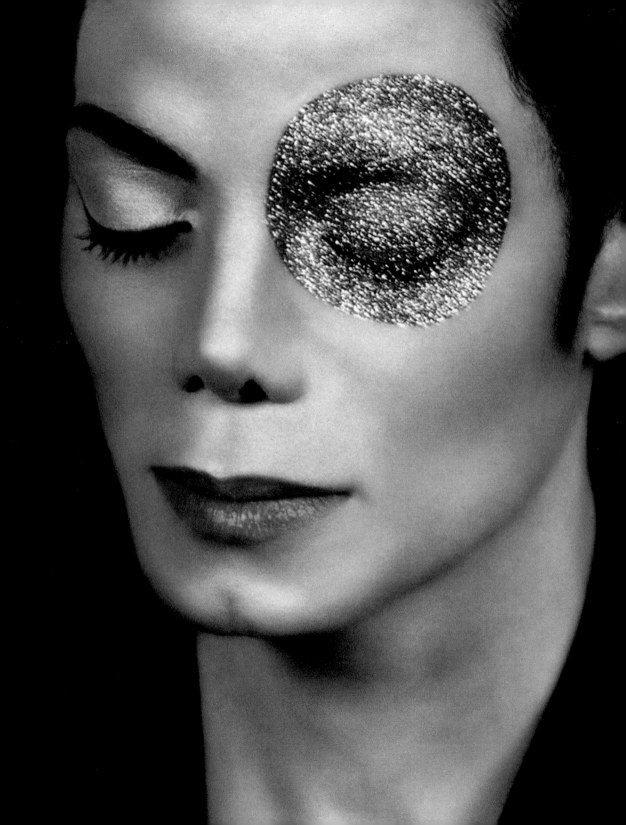

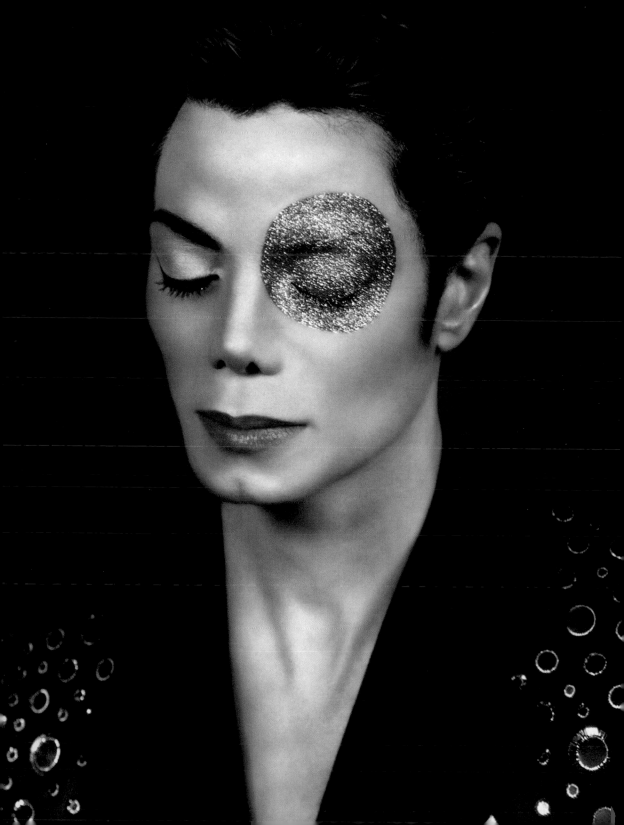

1

ARNO BANI (b. 1976)

Michael Jackson's Blue Eye, 1999

Unique print, 2010.

Lambda silver print.

Signed, dated, and numbered 1/1.

Print: 210 cm x 166.7 cm

Image: 200 cm x 156.7 cm

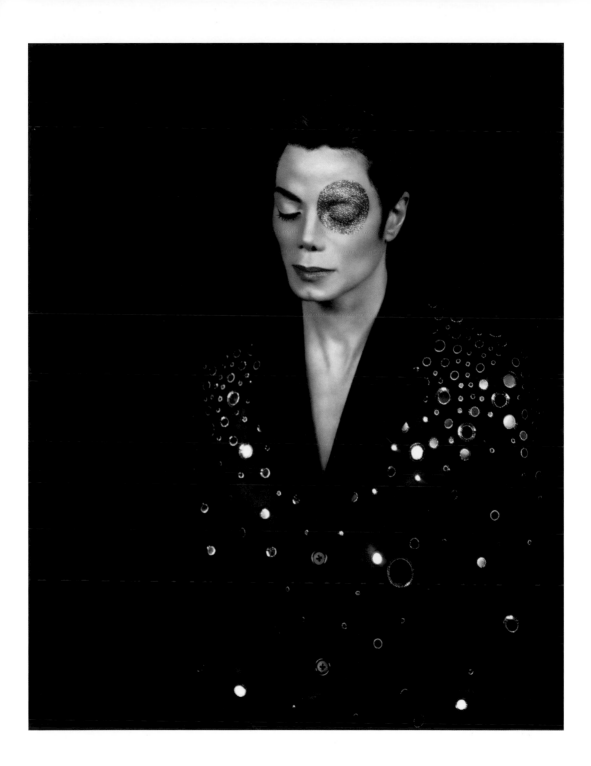

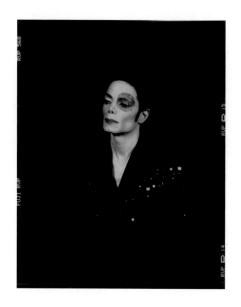

2
ARNO BANI (b. 1976)

Michael Jackson's Blue Eye n°2, 1999

Unique print, 2010.

Lambda silver print.

Signed, dated, and numbered 1/1.

Print: 9.7 cm x 7.8 cm

Image: 8.7 cm x 6.8 cm

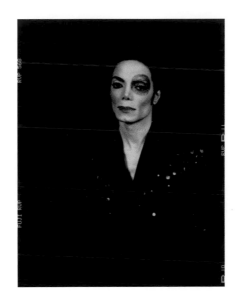

3

ARNO BANI (b. 1976)

Michael Jackson's Blue Eye n°3, 1999

Unique print, 2010.

Lambda silver print.

Signed, dated, and numbered 1/1.

Print: 9.7 cm x 7.8 cm

Image: 8.7 cm x 6.8 cm

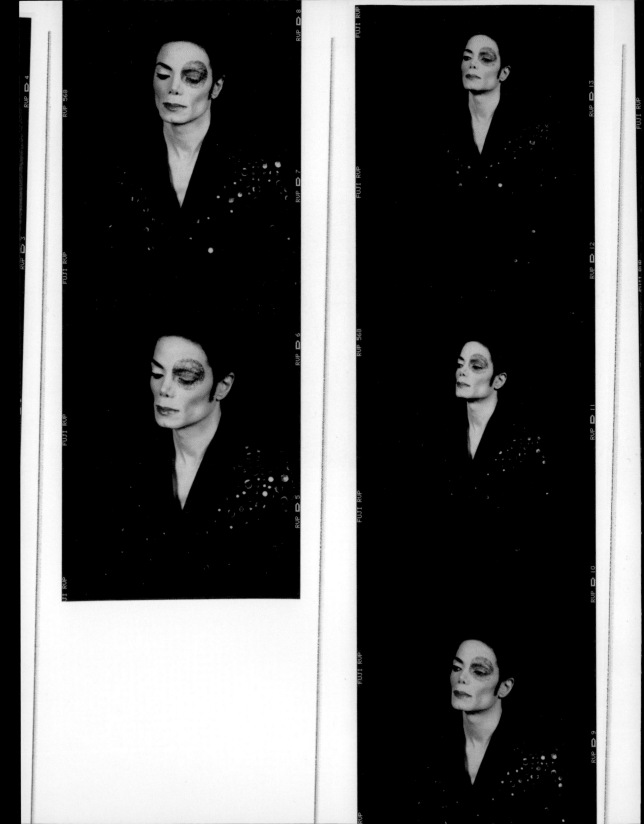

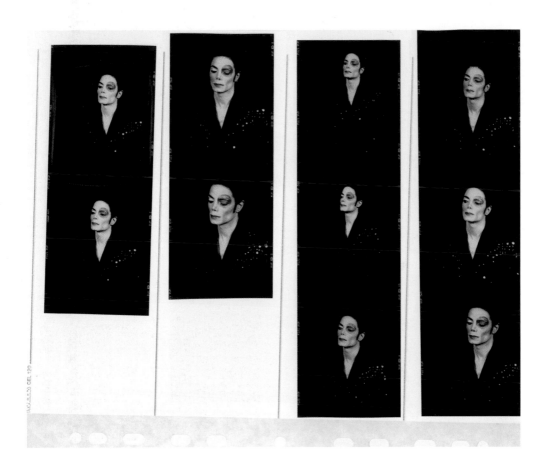

4

ARNO BANI (b. 1976)

Michael Jackson's Blue Eye, 1999

Contact sheet n°6. Unique print, 1999.

Contact sheet with ten images including one selected.

Color print on Fujicolor paper.

Signed, dated, and numbered 1/1.

25 cm x 29.7 cm

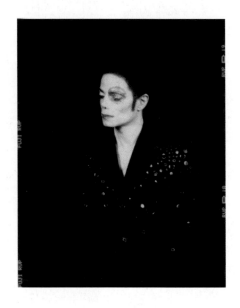

5

ARNO BANI (b. 1976)

Michael Jackson's Blue Eye n°4, 1999

Unique print, 2010.

Lambda silver print.

Signed, dated, and numbered 1/1.

Print: 9.7 cm x 7.8 cm

Image: 8.7 cm x 6.8 cm

An almost sacred stillness strips
away the drama and emphasizes the
mirror embroidery that covers
the Yves Saint Laurent tuxedo jacket
with sparkling rays of light.
Clean and precise, the truth of
a myth is captured in a fleeting
moment, like a memento mori.
As Shakespeare wrote, "Grace is grace,
despite of all controversy."

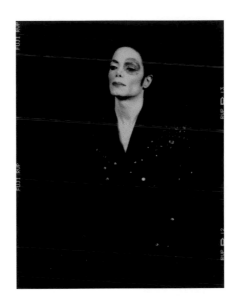

6

ARNO BANI (b. 1976)

Michael Jackson's Blue Eye n°5, 1999

Unique print, 2010.

Lambda silver print.

Signed, dated, and numbered 1/1.

Print: 9.7 cm x 7.8 cm

Image: 8.7 cm x 6.8 cm

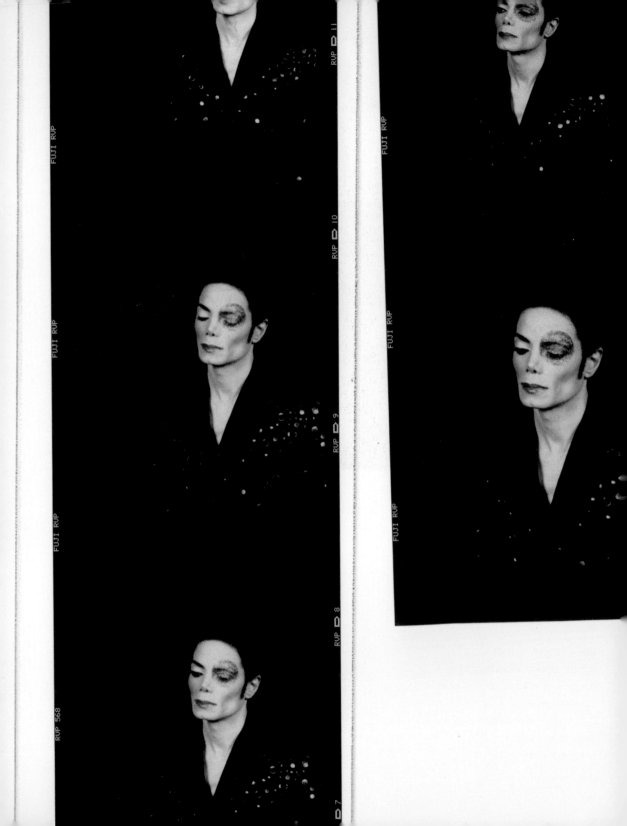

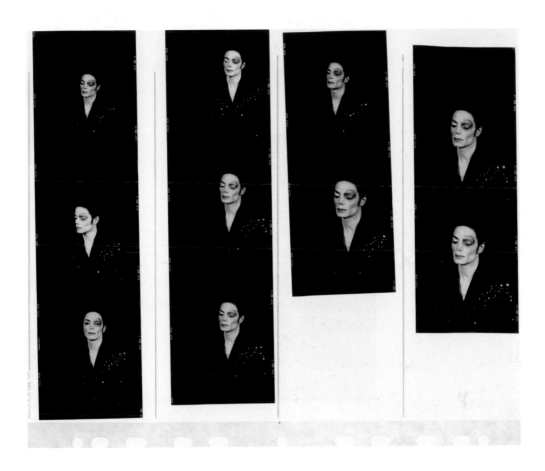

7

ARNO BANI (b. 1976)

Michael Jackson's Blue Eye, 1999

Contact sheet n°4. Unique print, 1999.

Contact sheet with ten images.

Color print on Fujicolor paper.

Signed, dated, and numbered 1/1.

25 cm x 29.7 cm

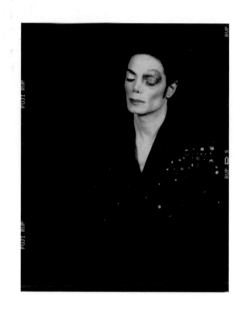

8

ARNO BANI (b. 1976)

Michael Jackson's Blue Eye n°6, 1999

Unique print, 2010.

Lambda silver print.

Signed, dated, and numbered 1/1.

Print: 9.7 cm x 7.8 cm

Image: 8.7 cm x 6.8 cm

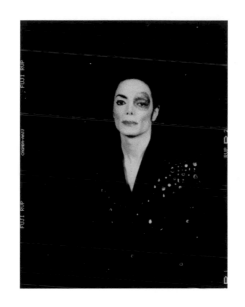

9

ARNO BANI (b. 1976)

Michael Jackson's Blue Eye n°7, 1999

Unique print, 2010.

Lambda silver print.

Signed, dated, and numbered 1/1.

Print: 9.7 cm x 7.8 cm

Image: 8.7 cm x 6.8 cm

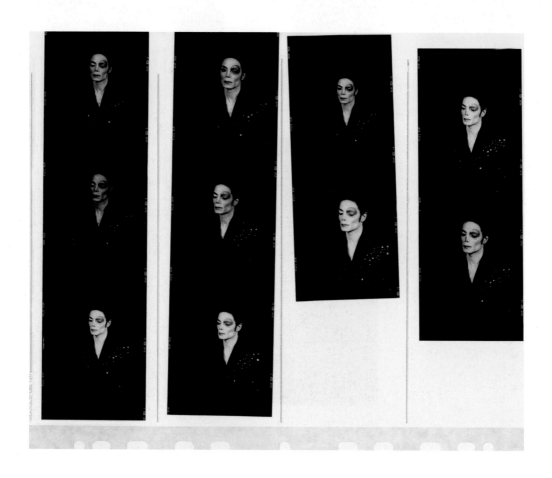

10

ARNO BANI (b. 1976)

Michael Jackson's Blue Eye, 1999

Contact sheet n°5. Unique print, 1999.

Contact sheet with ten images.

Color print on Fujicolor paper.

Signed, dated, and numbered 1/1.

25 cm x 29.7 cm

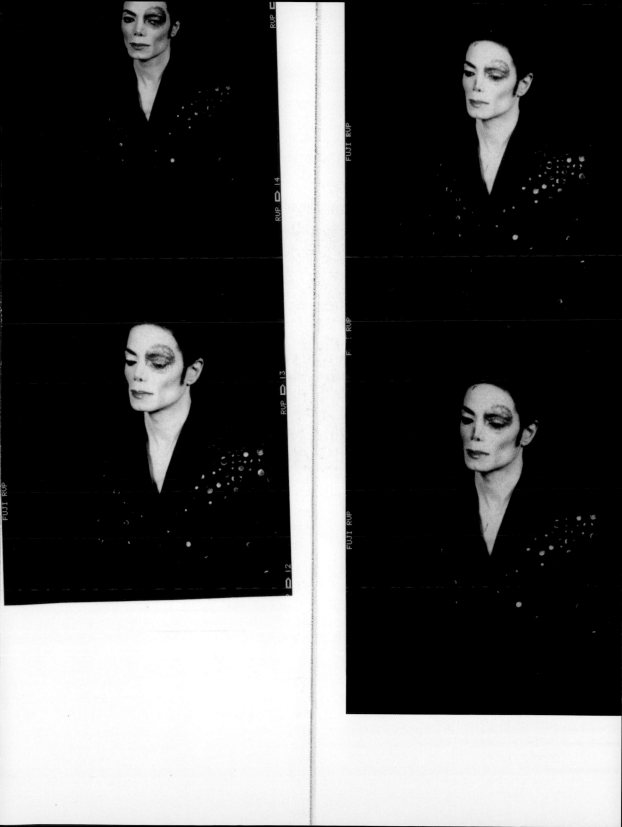

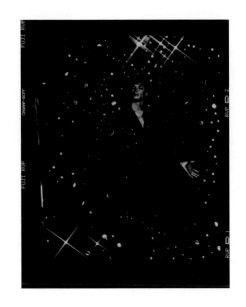

11

ARNO BANI (b. 1976)

Michael Jackson in the Stars n°1, 1999

Unique print, 2010.

Lambda silver print.

Signed, dated, and numbered 1/1.

Print: 9.7 cm x 7.8 cm

Image: 8.7 cm x 6.8 cm

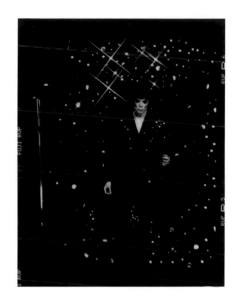

12

ARNO BANI (b. 1976)

Michael Jackson in the Stars n°2, 1999

Unique print, 2010.

Lambda silver print.

Signed, dated, and numbered 1/1.

Print: 9.7 cm x 7.8 cm

Image: 8.7 cm x 6.8 cm

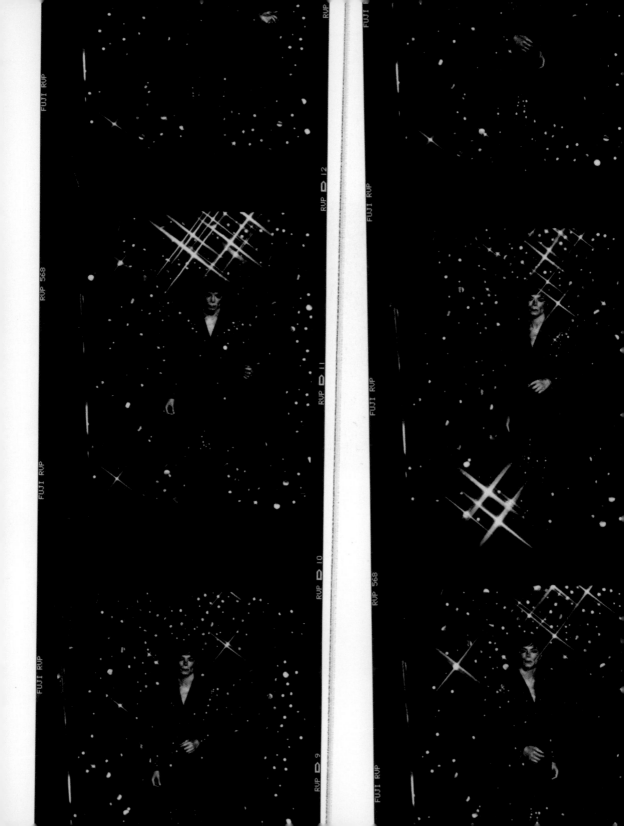

13

ARNO BANI (b. 1976)

Michael Jackson in the Stars, 1999

Contact sheet n°24. Unique print, 1999.

Contact sheet with ten images.

Color print on Fujicolor paper.

Signed, dated, and numbered 1/1.

25 cm x 29.7 cm

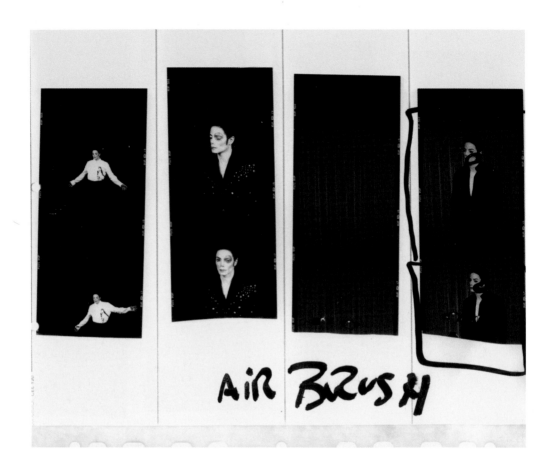

14

ARNO BANI (b. 1976)

Michael Jackson's Blue Eye, with Red Background, in White Shirt 1999

Contact sheet n°25. Unique print, 1999.

Contact sheet with eight images including two selected
and one handwritten note by Michael Jackson: *"Air Brush."*

Color print on Fujicolor paper.

Signed, dated, and numbered 1/1.

25 cm x 29.7 cm

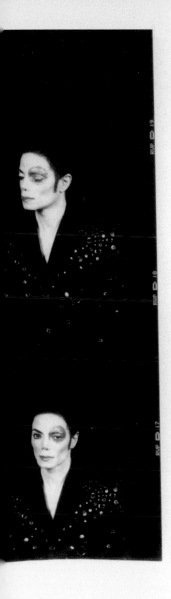

AiR BRUSH

MICHAEL JACKSON WITH
RED BACKGROUND

The most touching and perhaps
the most captivating of portraits:
the singer stands dreaming,
unguarded, reflective and solemn,
waiting for the stage lights to go out.

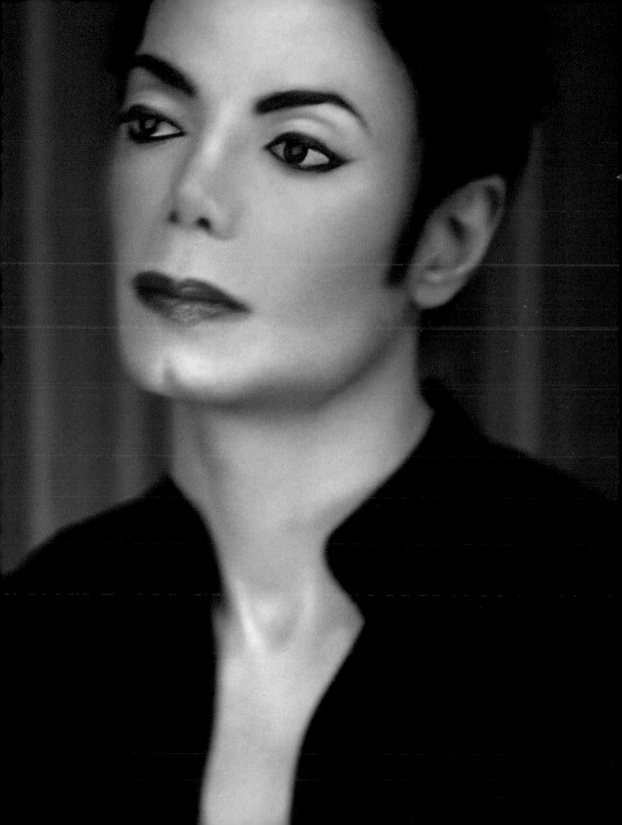

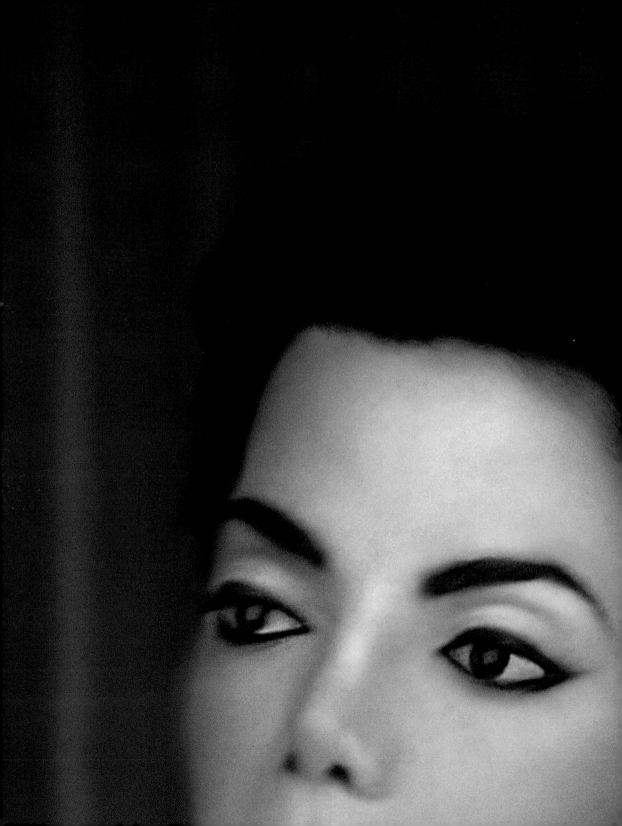

15

ARNO BANI (b. 1976)

Michael Jackson with Red Background, 1999

Unique print, 2010.

Lambda silver print.

Signed, dated, and numbered 1/1.

Print: 210 cm x 166.7 cm

Image: 200 cm x 156.7 cm

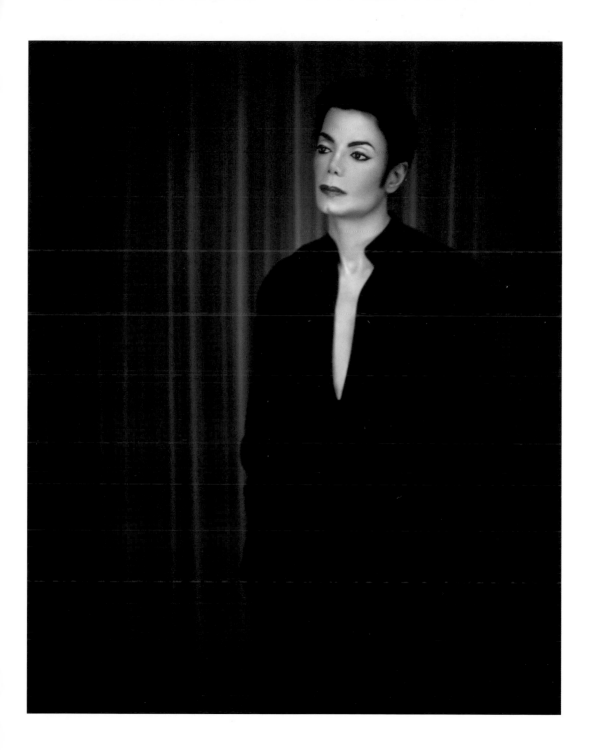

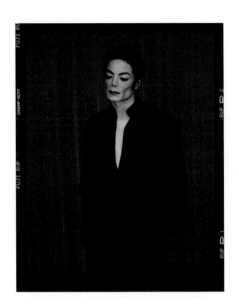

16

ARNO BANI (b. 1976)

Michael Jackson with Red Background n°2, 1999

Unique print, 2010.

Lambda silver print.

Signed, dated, and numbered 1/1.

Print: 9.7 cm x 7.8 cm

Image: 8.7 cm x 6.8 cm

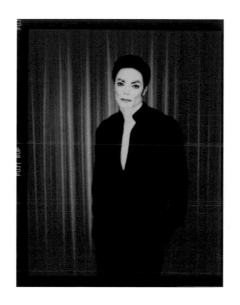

17
ARNO BANI (b. 1976)

Michael Jackson with Red Background n°3, 1999

Unique print, 2010.

Lambda silver print.

Signed, dated, and numbered 1/1.

Print: 9.7 cm x 7.8 cm

Image: 8.7 cm x 6.8 cm

The red curtain falls
and Michael tips his hat
before taking a final bow.

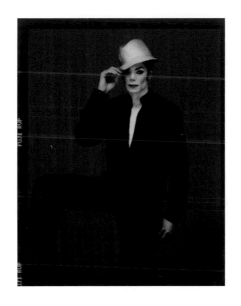

18

ARNO BANI (b. 1976)

Michael Jackson with Red Background n°4, 1999

Unique print, 2010.

Lambda silver print.

Signed, dated, and numbered 1/1.

Print: 9.7 cm x 7.8 cm

Image: 8.7 cm x 6.8 cm

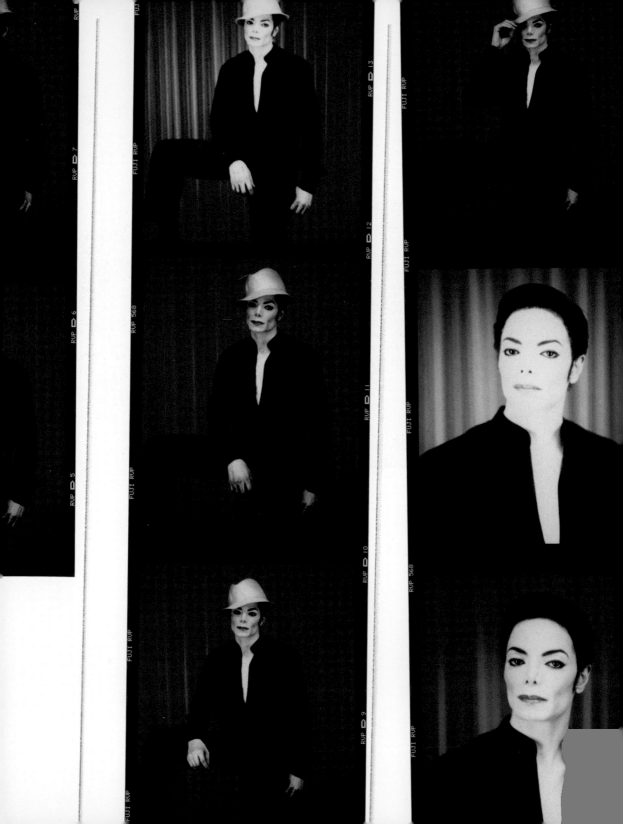

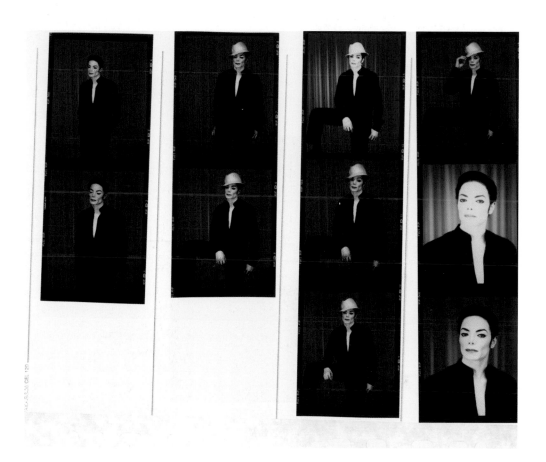

19

ARNO BANI (b. 1976)

Michael Jackson with Red Background, 1999

Contact sheet n°8. Unique print, 1999.

Contact sheet with ten images.

Color print on Fujicolor paper.

Signed, dated, and numbered 1/1.

25 cm x 29.7 cm

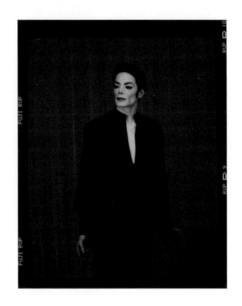

20

ARNO BANI (b. 1976)

Michael Jackson with Red Background n°5, 1999

Unique print, 2010.

Lambda silver print.

Signed, dated, and numbered 1/1.

Print: 9.7 cm x 7.8 cm

Image: 8.7 cm x 6.8 cm

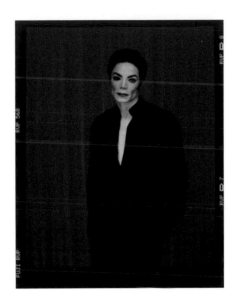

21

ARNO BANI (b. 1976)

Michael Jackson with Red Background n°6, 1999

Unique print, 2010.

Lambda silver print.

Signed, dated, and numbered 1/1.

Print: 9.7 cm x 7.8 cm

Image: 8.7 cm x 6.8 cm

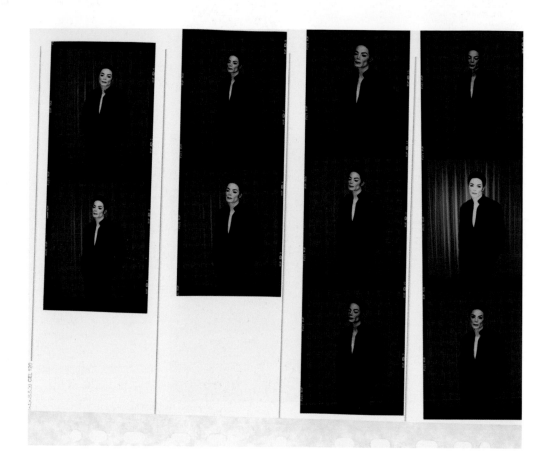

22

ARNO BANI (b. 1976)

Michael Jackson with Red Background, 1999

Contact sheet n°9. Unique print, 1999.

Contact sheet with ten images.

Color print on Fujicolor paper.

Signed, dated, and numbered 1/1.

25 cm x 29.7 cm

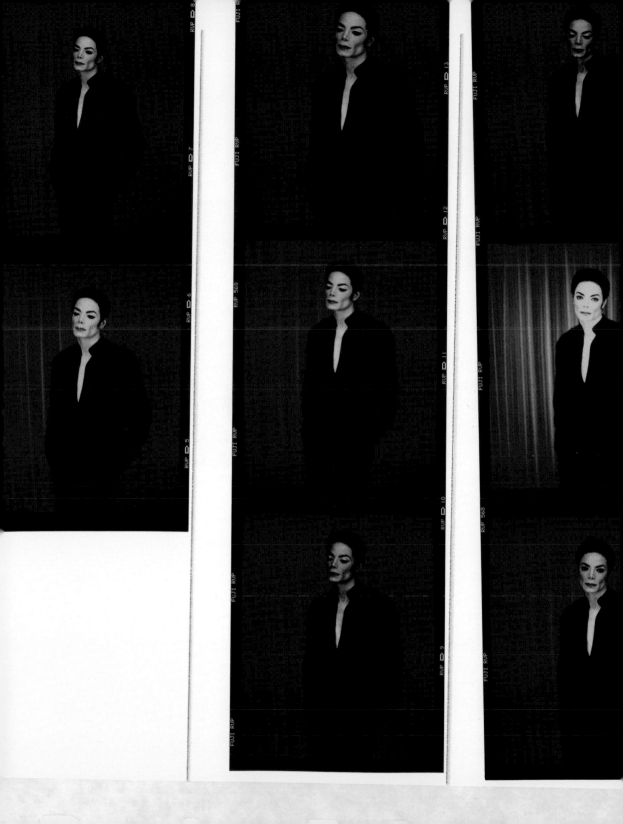

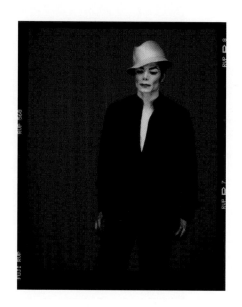

23

ARNO BANI (b. 1976)

Michael Jackson with Red Background n°7, 1999

Unique print, 2010.

Lambda silver print.

Signed, dated, and numbered 1/1.

Print: 9.7 cm x 7.8 cm

Image: 8.7 cm x 6.8 cm

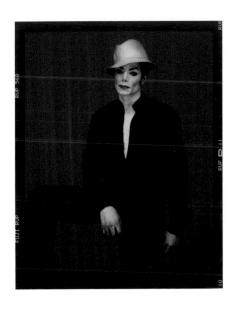

24
ARNO BANI (b. 1976)

Michael Jackson with Red Background n°8, 1999

Unique print, 2010.

Lambda silver print.

Signed, dated, and numbered 1/1.

Print: 9.7 cm x 7.8 cm

Image: 8.7 cm x 6.8 cm

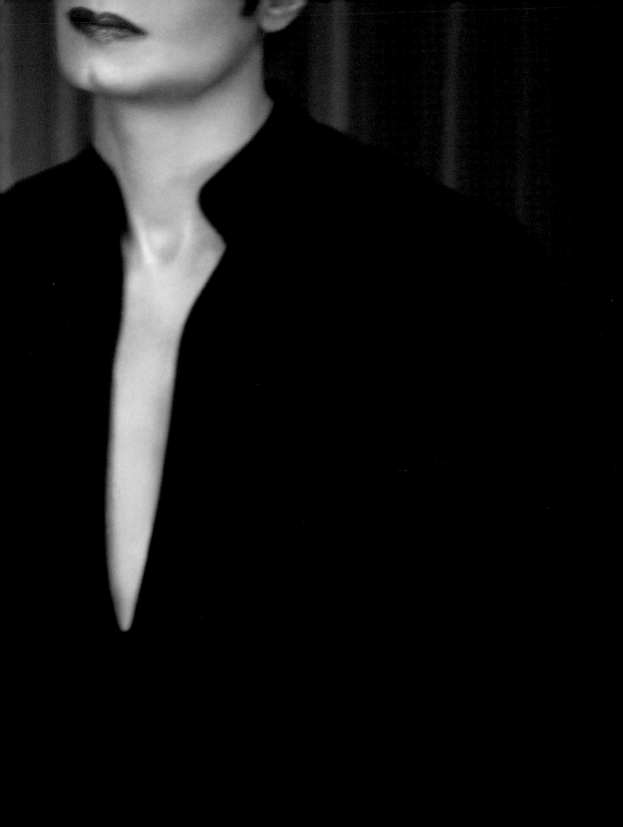

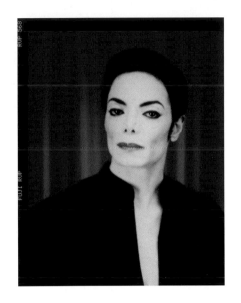

25

ARNO BANI (b. 1976)

Michael Jackson with Red Background n°9, 1999

Unique print, 2010.

Lambda silver print.

Signed, dated, and numbered 1/1.

Print: 9.7 cm x 7.8 cm

Image: 8.7 cm x 6.8 cm

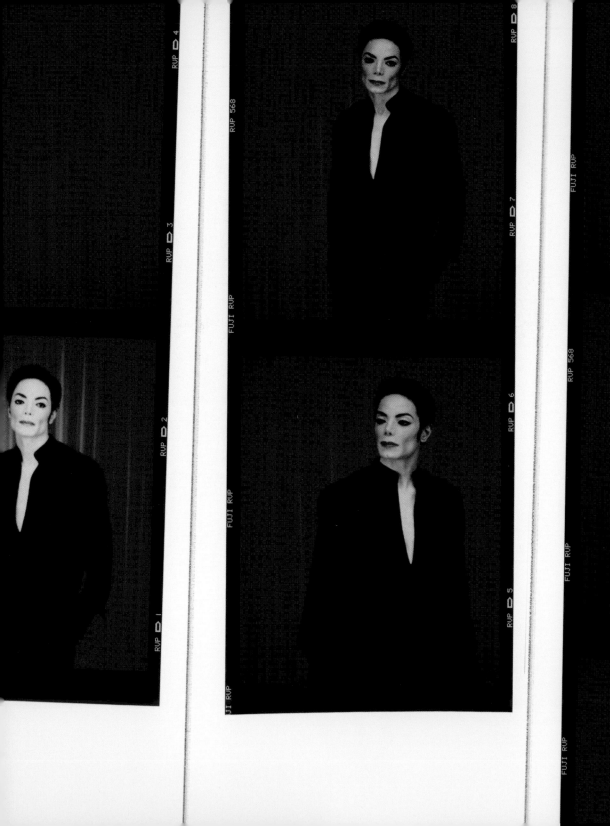

26

ARNO BANI (b. 1976)

Michael Jackson with Red Background, 1999

Contact sheet n°7. Unique print, 1999.

Contact sheet with ten images.

Color print on Fujicolor paper.

Signed, dated, and numbered 1/1.

25 cm x 29.7 cm

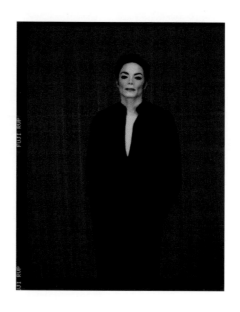

27

ARNO BANI (b. 1976)

Michael Jackson with Red Background n°10, 1999

Unique print, 2010.

Lambda silver print.

Signed, dated, and numbered 1/1.

Print: 9.7 cm x 7.8 cm

Image: 8.7 cm x 6.8 cm

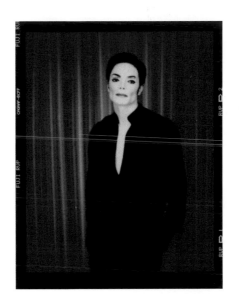

28

ARNO BANI (b. 1976)

Michael Jackson with Red Background n°11, 1999

Unique print, 2010.

Lambda silver print.

Signed, dated, and numbered 1/1.

Print: 9.7 cm x 7.8 cm

Image: 8.7 cm x 6.8 cm

MICHAEL JACKSON IN
THE GOLDEN CAPE

The image of a boy king or a young god, enveloped in a soft halo of glowing light, like the dawn or the sunset. He seems to reign over the earth, impassive, enigmatic, and bare beneath a heavy cloak of gold.

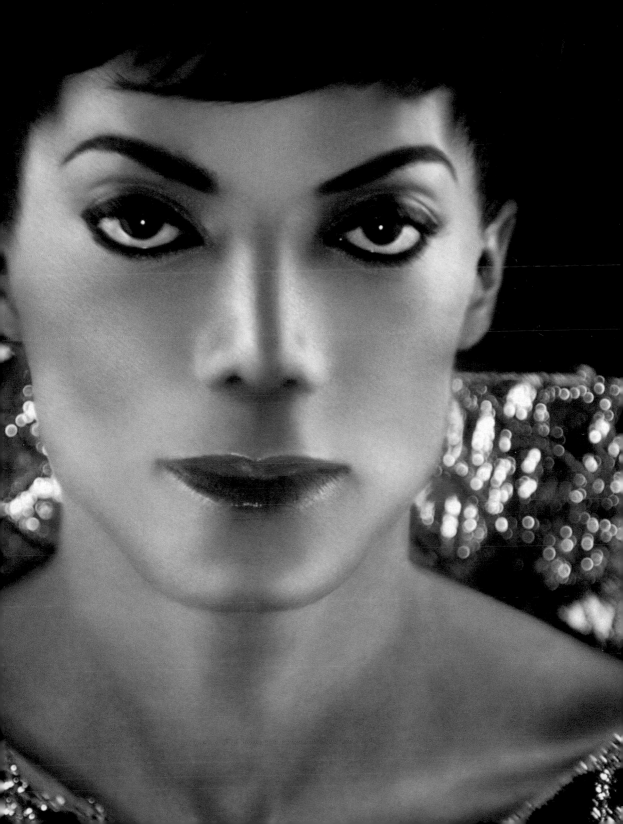

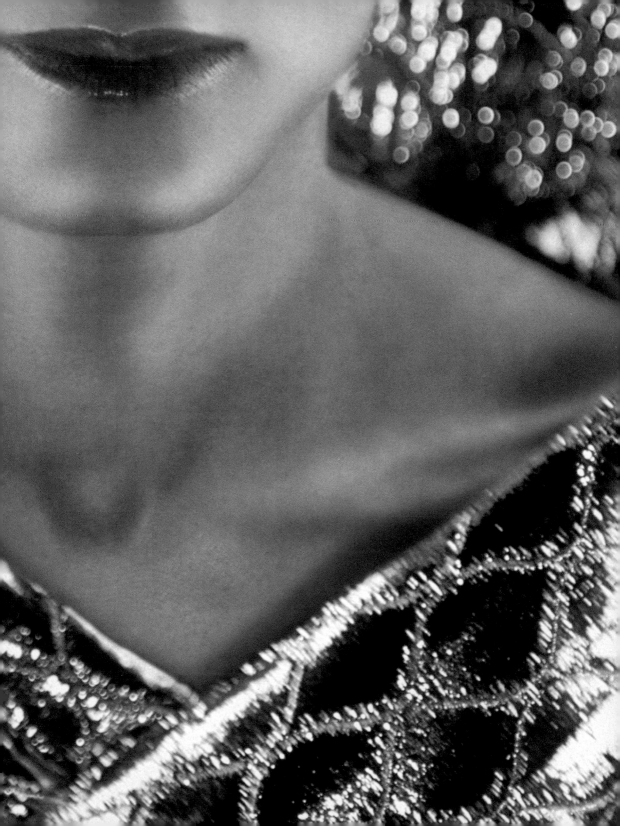

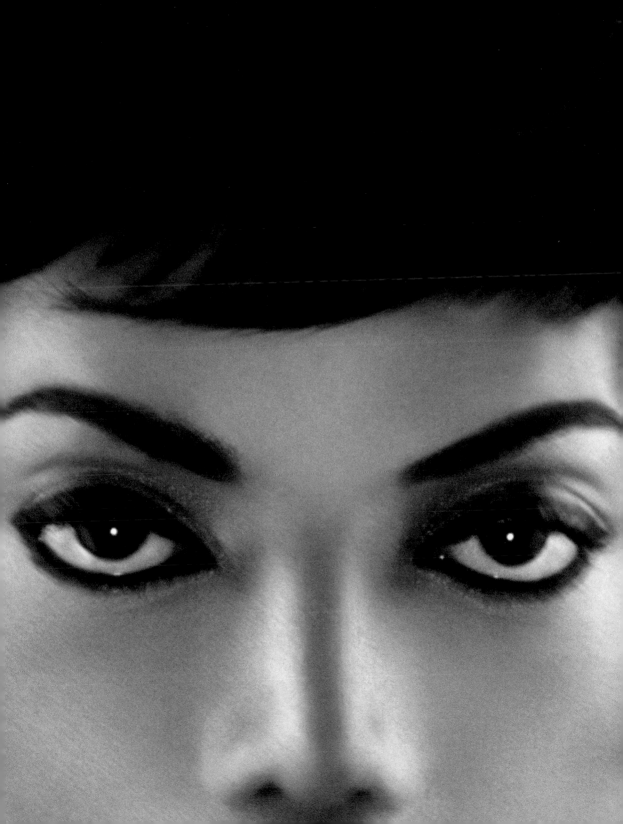

29

ARNO BANI (b. 1976)

Michael Jackson in the Golden Cape, 1999

Unique print, 2010.

Lambda silver print.

Signed, dated, and numbered 1/1.

Print: 210 cm x 166.7 cm

Image: 200 cm x 156.7 cm

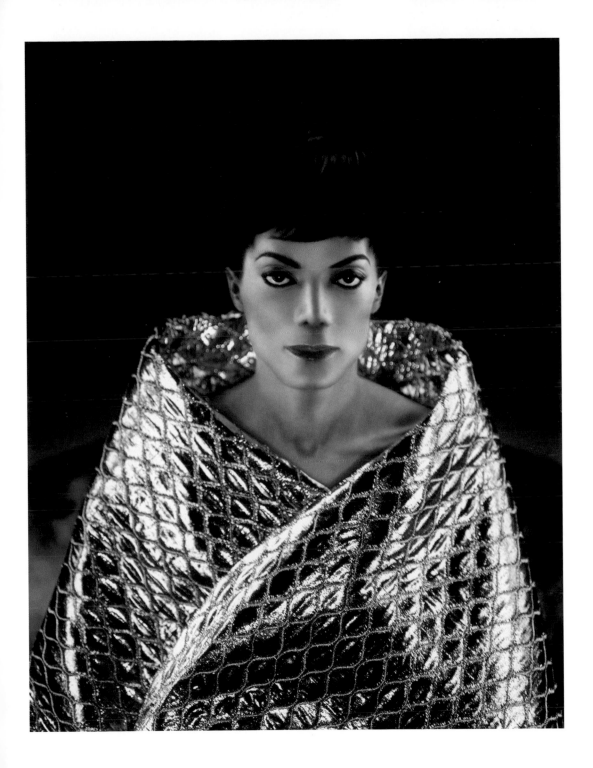

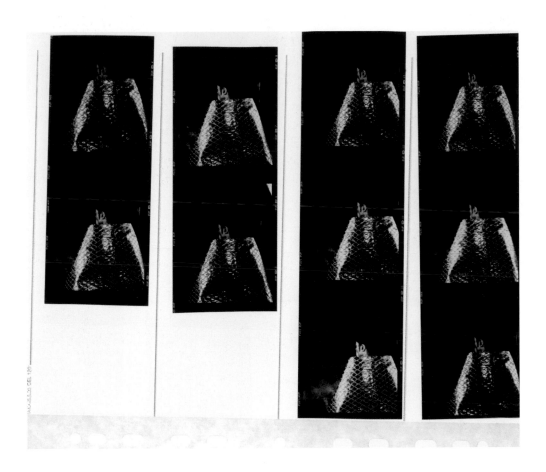

30

ARNO BANI (b. 1976)

Michael Jackson in the Golden Cape, 1999

Contact sheet n°14. Unique print, 1999.

Contact sheet with ten images.

Color print on Fujicolor paper.

Signed, dated, and numbered 1/1.

25 cm x 29.7 cm

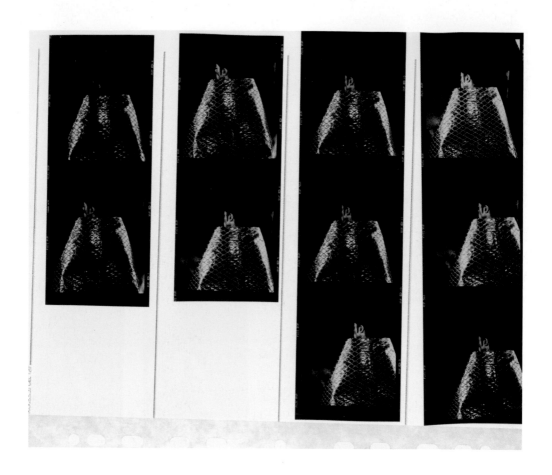

31

ARNO BANI (b. 1976)

Michael Jackson in the Golden Cape, 1999

Contact sheet n°13. Unique print, 1999.

Contact sheet with ten images.

Color print on Fujicolor paper.

Signed, dated, and numbered 1/1.

25 cm x 29.7 cm

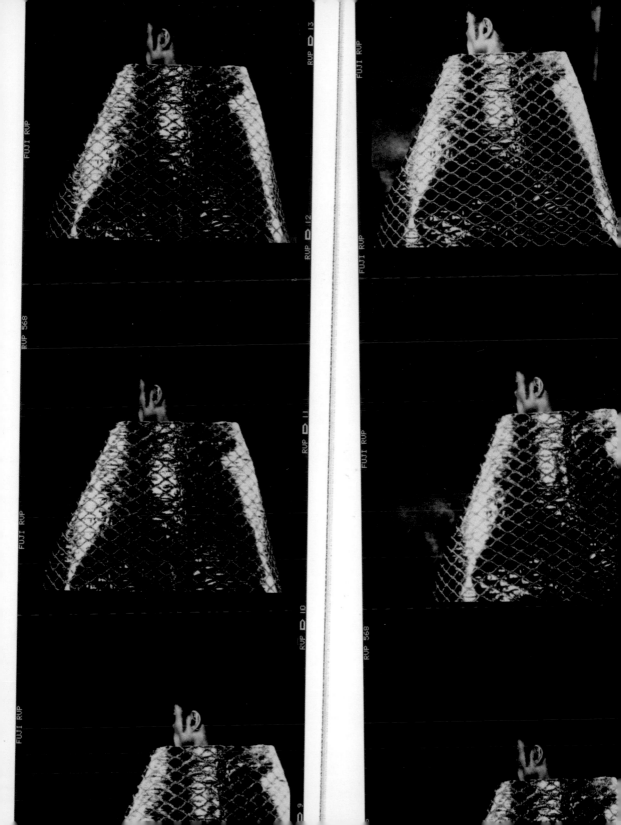

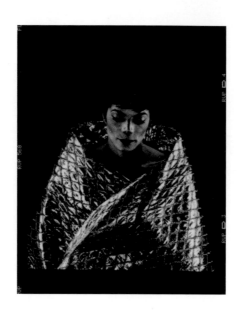

32

ARNO BANI (b. 1976)

Michael Jackson in the Golden Cape n°2, 1999

Unique print, 2010.

Lambda silver print.

Signed, dated, and numbered 1/1.

Print: 9.7 cm x 7.8 cm

Image: 8.7 cm x 6.8 cm

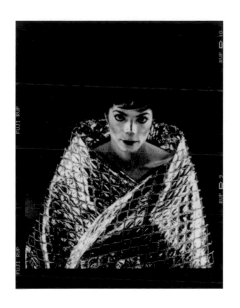

33
ARNO BANI (b. 1976)

Michael Jackson in the Golden Cape n°3, 1999

Unique print, 2010.

Lambda silver print.

Signed, dated, and numbered 1/1.

Print: 9.7 cm x 7.8 cm

Image: 8.7 cm x 6.8 cm

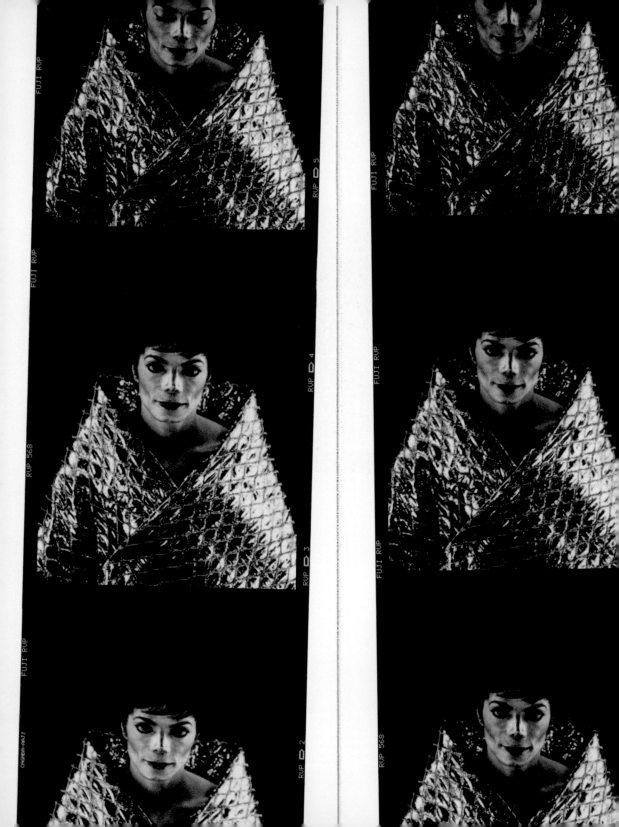

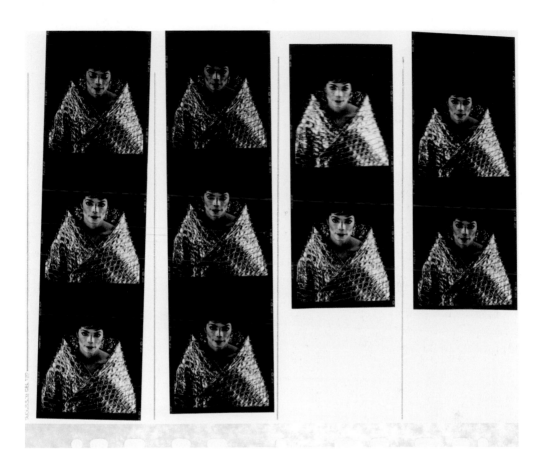

34

ARNO BANI (b. 1976)

Michael Jackson in the Golden Cape, 1999

Contact sheet n°12. Unique print, 1999.

Contact sheet with ten images.

Color print on Fujicolor paper.

Signed, dated, and numbered 1/1.

25 cm x 29.7 cm

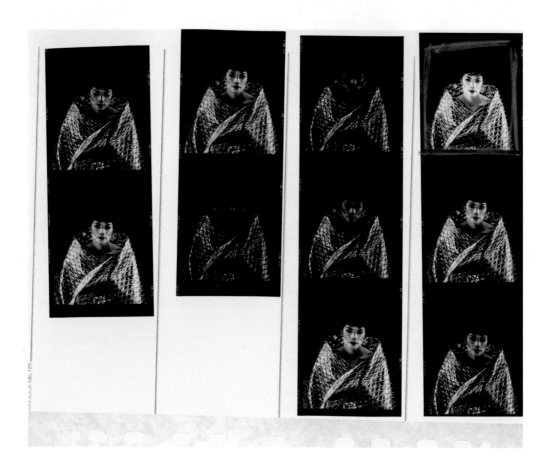

35

ARNO BANI (b. 1976)

Michael Jackson in the Golden Cape, 1999

Contact sheet n°11. Unique print, 1999.

Contact sheet with ten images including one selected.

Color print on Fujicolor paper.

Signed, dated, and numbered 1/1.

25 cm x 29.7 cm

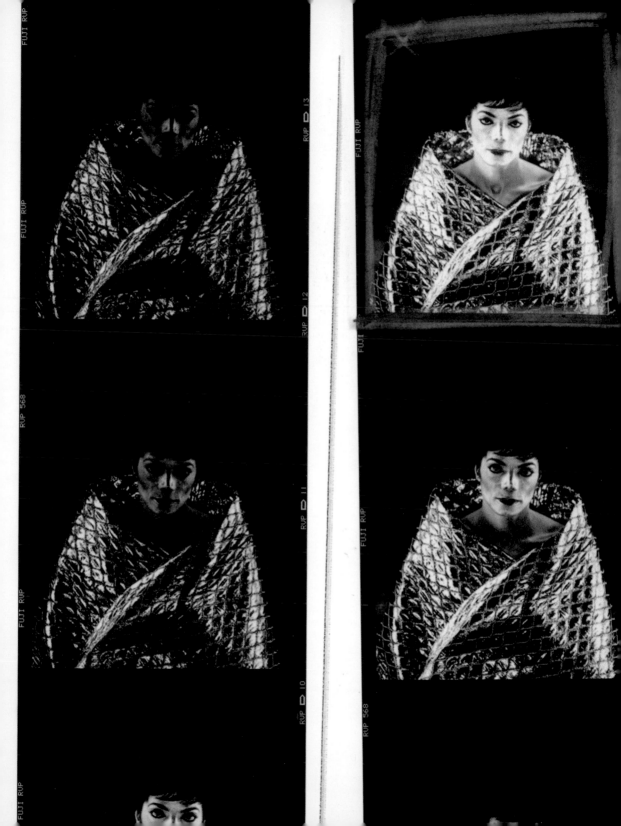

36

ARNO BANI (b. 1976)

Michael Jackson in the Golden Cape n°4, 1999

Unique print, 2010.

Lambda silver print.

Signed, dated, and numbered 1/1.

Print: 9.7 cm x 7.8 cm

Image: 8.7 cm x 6.8 cm

37

ARNO BANI (b. 1976)

Michael Jackson in the Golden Cape n°5, 1999

Unique print, 2010.

Lambda silver print.

Signed, dated, and numbered 1/1.

Print: 9.7 cm x 7.8 cm

Image: 8.7 cm x 6.8 cm

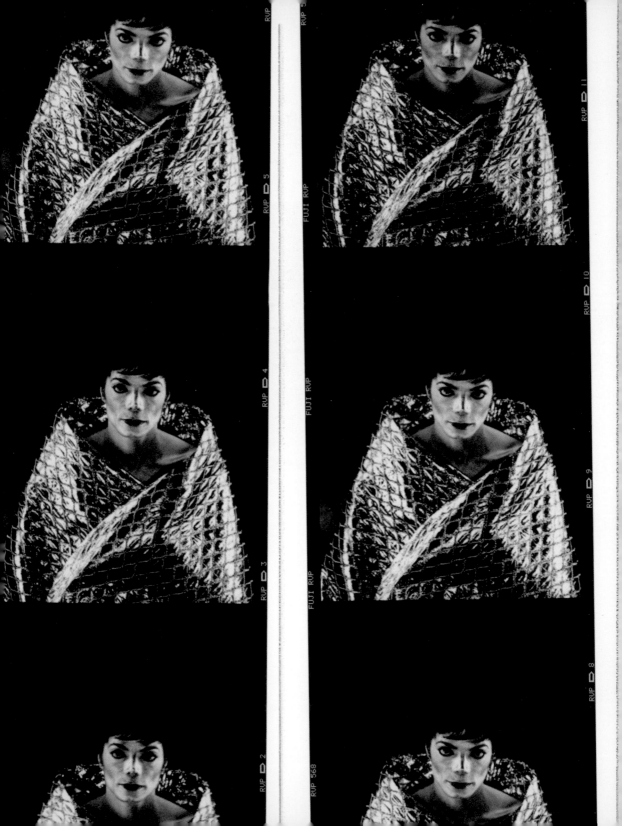

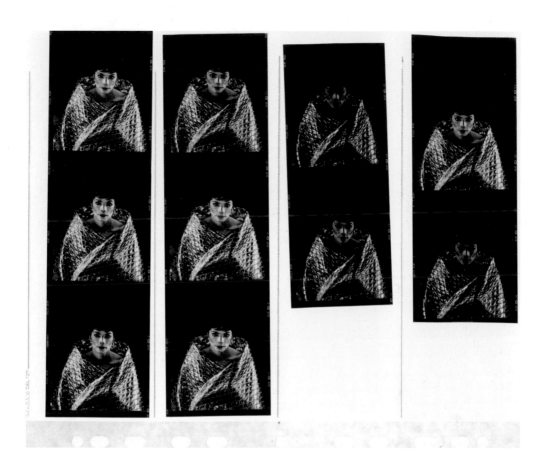

38

ARNO BANI (b. 1976)

Michael Jackson in the Golden Cape, 1999

Contact sheet n°17. Unique print, 1999.

Contact sheet with ten images.

Color print on Fujicolor paper.

Signed, dated, and numbered 1/1.

25 cm x 29.7 cm

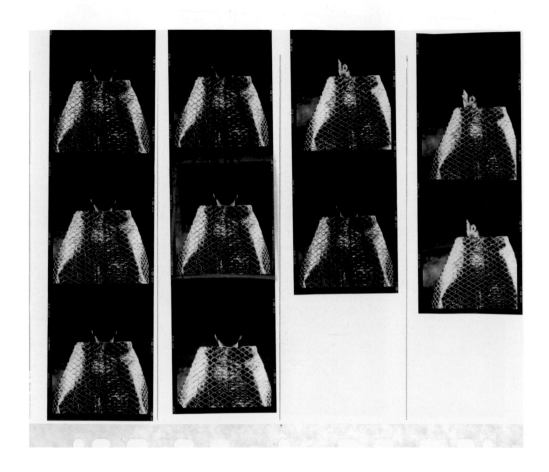

39

ARNO BANI (b. 1976)

Michael Jackson in the Golden Cape, 1999

Contact sheet n°16. Unique print, 1999.

Contact sheet with ten images including one selected.

Color print on Fujicolor paper.

Signed, dated, and numbered 1/1.

25 cm x 29.7 cm

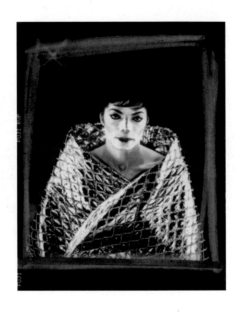

40

ARNO BANI (b. 1976)

Michael Jackson in the Golden Cape n°6, 1999

Unique print, 2010.

Lambda silver print.

Signed, dated, and numbered 1/1.

Print: 9.7 cm x 7.8 cm

Image: 8.7 cm x 6.8 cm

41

ARNO BANI (b. 1976)

Michael Jackson in the Golden Cape, 1999

Contact sheet n°21. Unique print, 1999.

Contact sheet with ten images.

Color print on Fujicolor paper.

Signed, dated, and numbered 1/1.

25 cm x 29.7 cm

42

ARNO BANI (b. 1976)

Michael Jackson in the Golden Cape, 1999

Contact sheet n°20. Unique print, 1999.

Contact sheet with ten images.

Color print on Fujicolor paper.

Signed, dated, and numbered 1/1.

25 cm x 29.7 cm

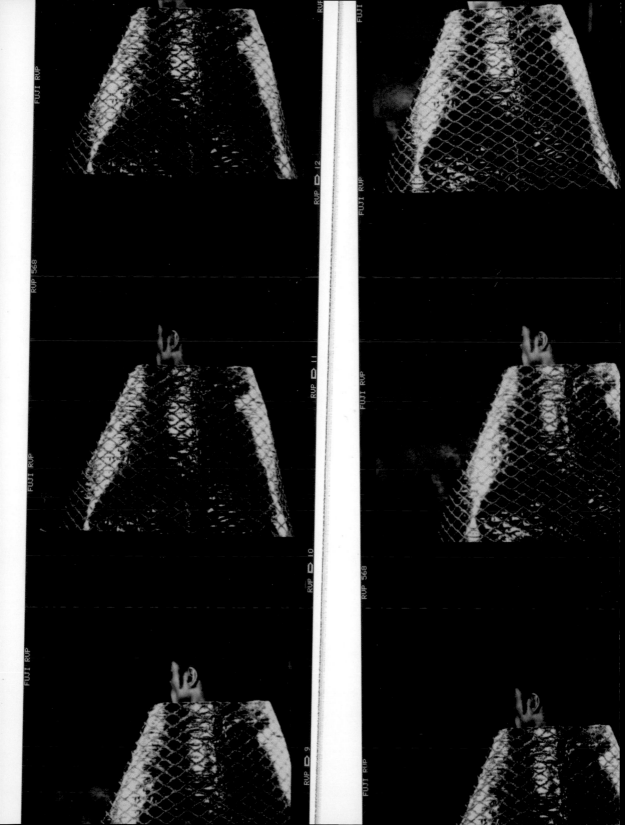

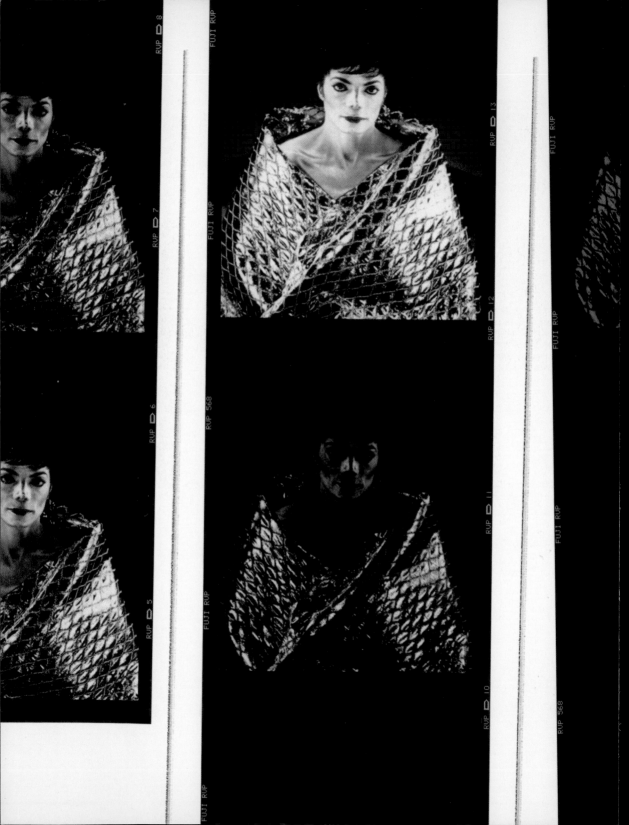

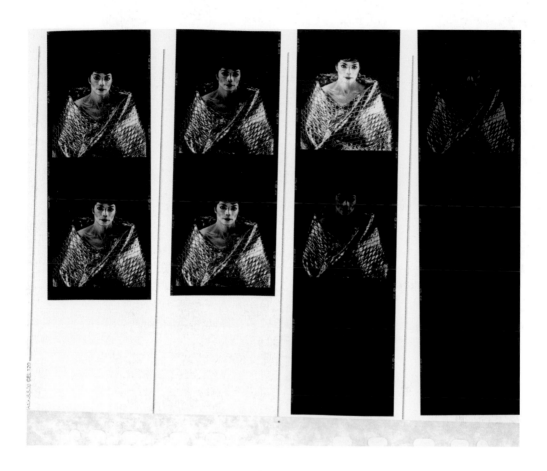

43

ARNO BANI (b. 1976)

Michael Jackson in the Golden Cape, 1999

Contact sheet n°10. Unique print, 1999.

Contact sheet with seven images.

Color print on Fujicolor paper.

Signed, dated, and numbered 1/1.

25 cm x 29.7 cm

Beneath the smooth fringe
of short hair lie dark eyes that could
have come from an Egyptian portrait,
clear and timeless, gazing out
but never seeing.

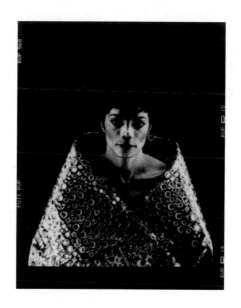

44

ARNO BANI (b. 1976)

Michael Jackson in the Embroidered Golden Cape n°7, 1999

Unique print, 2010.

Lambda silver print.

Signed, dated, and numbered 1/1.

Print: 9.7 cm x 7.8 cm

Image: 8.7 cm x 6.8 cm

45

ARNO BANI (b. 1976)

Michael Jackson in the Embroidered Golden Cape n°7, 1999

Contact sheet n°19. Unique print, 1999.

Contact sheet with ten images.

Color print on Fujicolor paper.

Signed, dated, and numbered 1/1.

25 cm x 29.7 cm

46

ARNO BANI (b. 1976)

Michael Jackson in the Embroidered Golden Cape, 1999

Contact sheet n°15. Unique print, 1999.

Contact sheet with ten images.

Color print on Fujicolor paper.

Signed, dated, and numbered 1/1.

25 cm x 29.7 cm

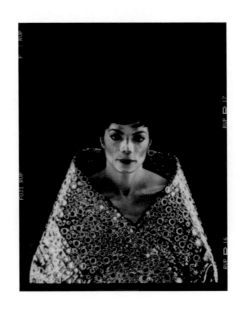

47

ARNO BANI (b. 1976)

Michael Jackson in the Embroidered Golden Cape n°8, 1999

Unique print, 2010.

Lambda silver print.

Signed, dated, and numbered 1/1.

Print: 9.7 cm x 7.8 cm

Image: 8.7 cm x 6.8 cm

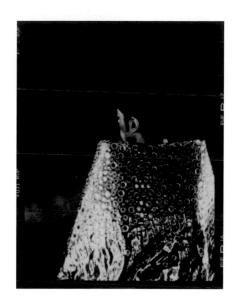

48

ARNO BANI (b. 1976)

Michael Jackson in the Embroidered Golden Cape n°9, 1999

Unique print, 2010.

Lambda silver print.

Signed, dated, and numbered 1/1.

Print: 9.7 cm x 7.8 cm

Image: 8.7 cm x 6.8 cm

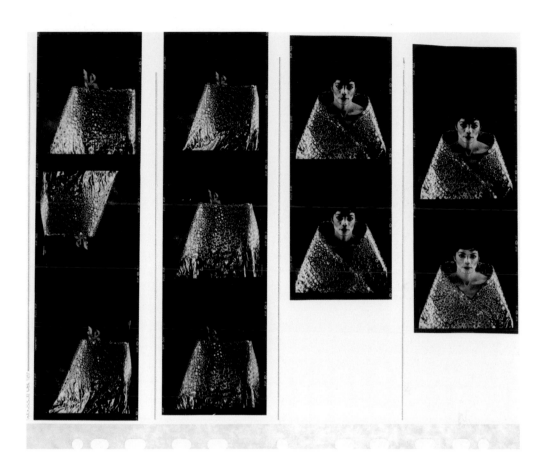

49

ARNO BANI (b. 1976)

Michael Jackson in the Embroidered Golden Cape, 1999

Contact sheet n°18. Unique print, 1999.

Contact sheet with ten images.

Color print on Fujicolor paper.

Signed, dated, and numbered 1/1.

25 cm x 29.7 cm

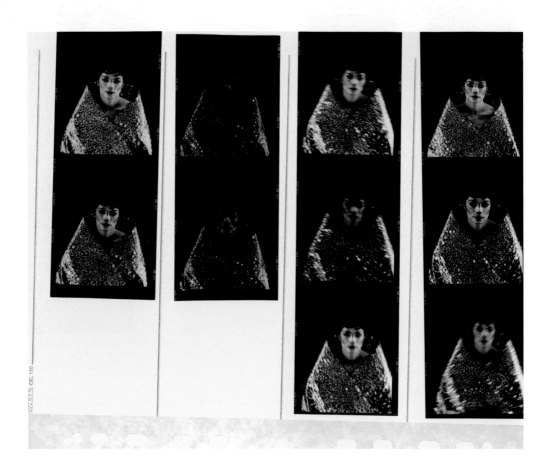

50

ARNO BANI (b. 1976)

Michael Jackson in the Embroidered Golden Cape, 1999

Contact sheet n°22. Unique print, 1999.

Contact sheet with ten images.

Color print on Fujicolor paper.

Signed, dated, and numbered 1/1.

25 cm x 29.7 cm

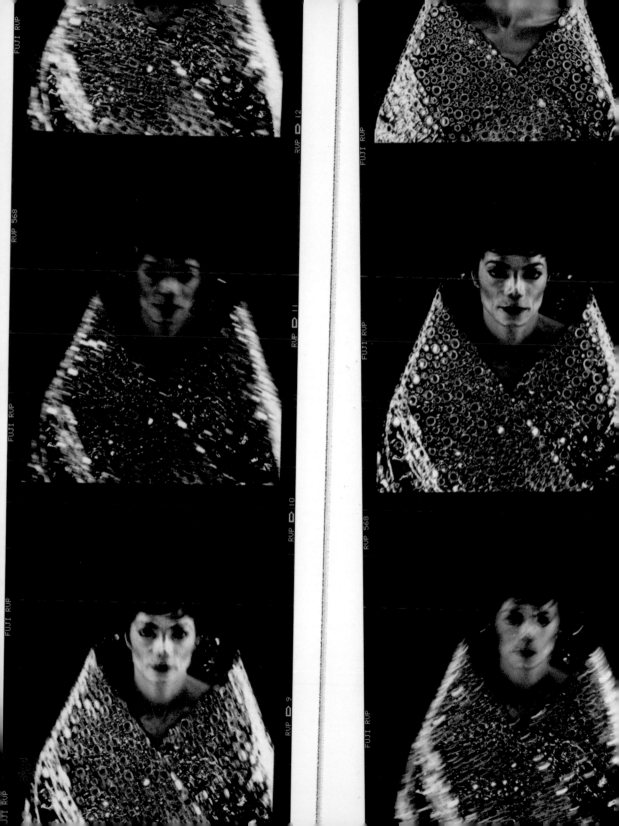

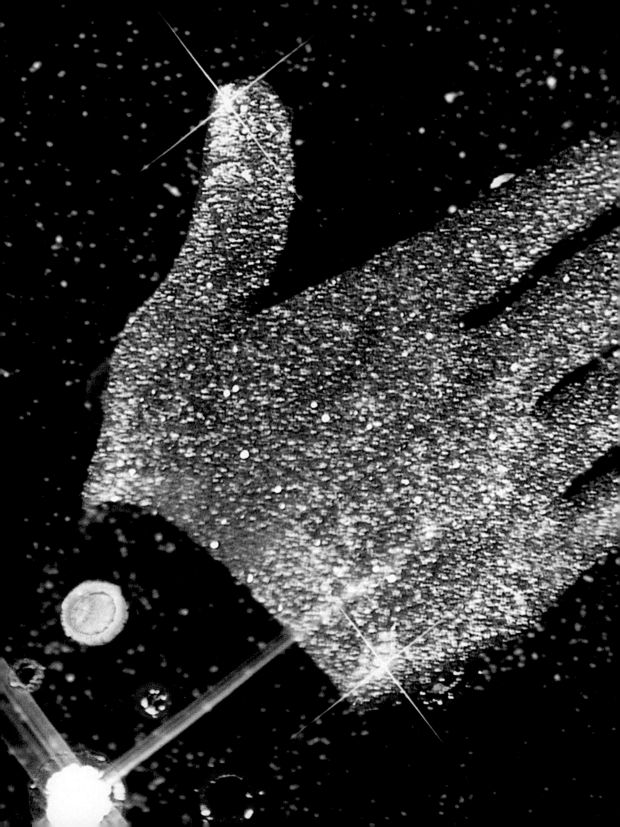

MICHAEL JACKSON WITH
THE SILVER HAND

Silver hand on his heart, a young man in a mask becomes an otherworldly being, a fugitive from a faraway galaxy that has left him sprinkled with stardust, and where he dreams of returning one day.

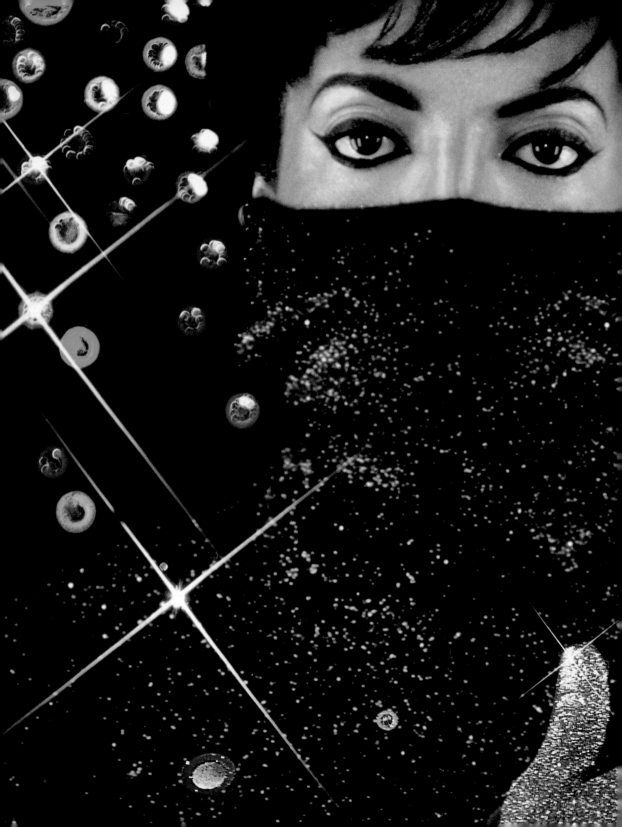

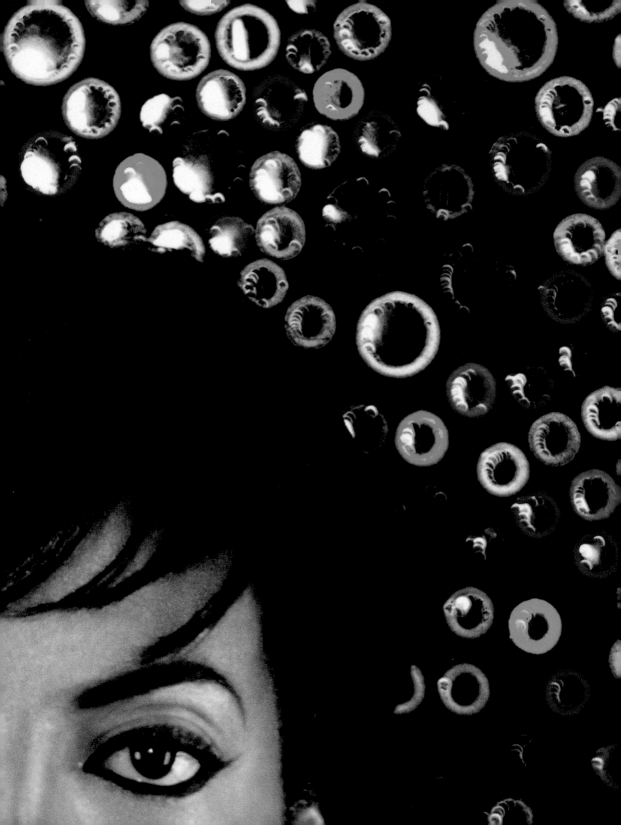

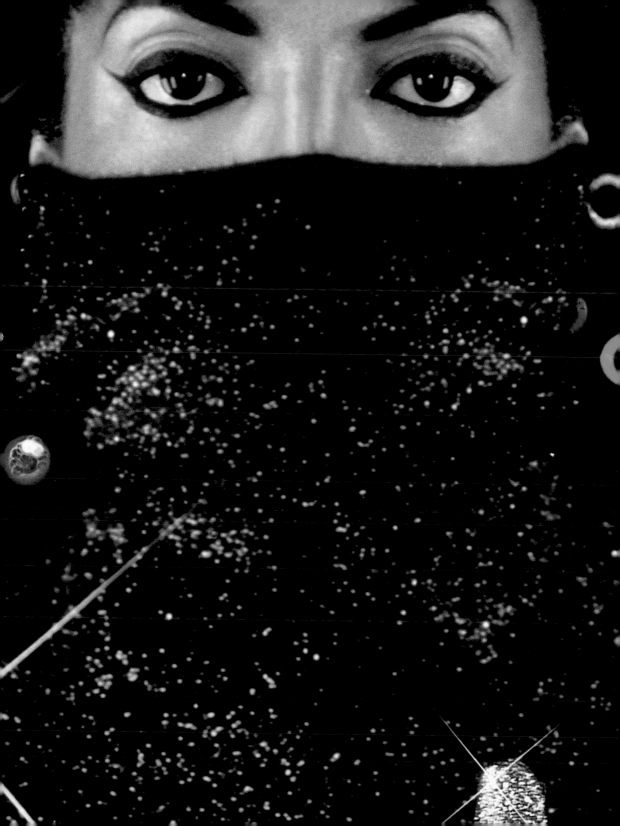

51

ARNO BANI (b. 1976)

Michael Jackson with the Silver Hand, 1999

Unique print, 2010.

Lambda silver print.

Signed, dated, and numbered 1/1.

Print: 210 cm x 166.7 cm

Image: 200 cm x 156.7 cm

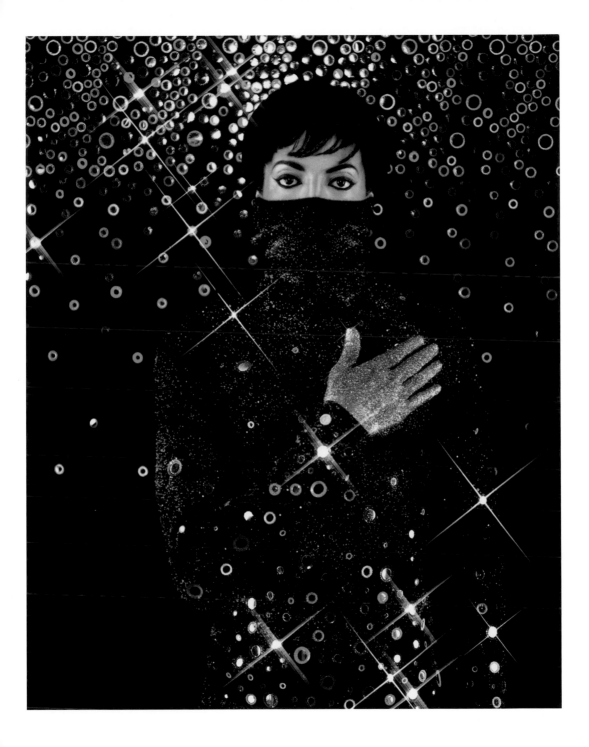

52

ARNO BANI (b. 1976)

Michael Jackson with the Silver Hand n°2, 1999

Unique print, 2010.

Lambda silver print.

Signed, dated, and numbered 1/1.

Print: 9.7 cm x 7.8 cm

Image: 8.7 cm x 6.8 cm

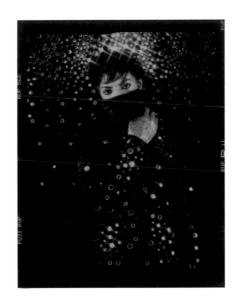

53

ARNO BANI (b. 1976)

Michael Jackson with the Silver Hand n°3, 1999

Unique print, 2010.

Lambda silver print.

Signed, dated, and numbered 1/1.

Print: 9.7 cm x 7.8 cm

Image: 8.7 cm x 6.8 cm

Like Howard Hughes,
he creates worlds and shoots
through the skies at lightning speed.
His eyes are all that can be seen,
childlike and gentle, always seeking
the unreachable star.

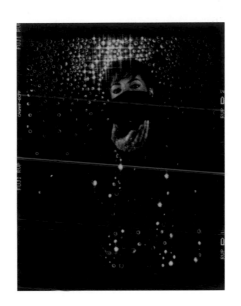

54

ARNO BANI (b. 1976)

Michael Jackson with the Silver Hand n°4, 1999

Unique print, 2010.

Lambda silver print.

Signed, dated, and numbered 1/1.

Print: 9.7 cm x 7.8 cm

Image: 8.7 cm x 6.8 cm

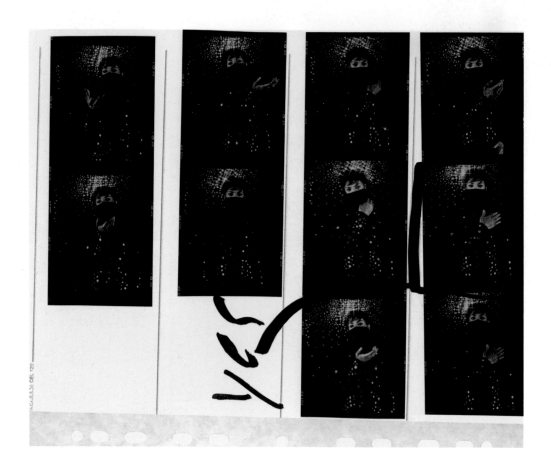

55

ARNO BANI (b. 1976)

Michael Jackson with the Silver Hand, 1999

Contact sheet n°23. Unique print, 1999.

Contact sheet with ten images including one selected

and one handwritten note by Michael Jackson: *"yes."*

Color print on Fujicolor paper.

Signed, dated, and numbered 1/1.

25 cm x 29.7 cm

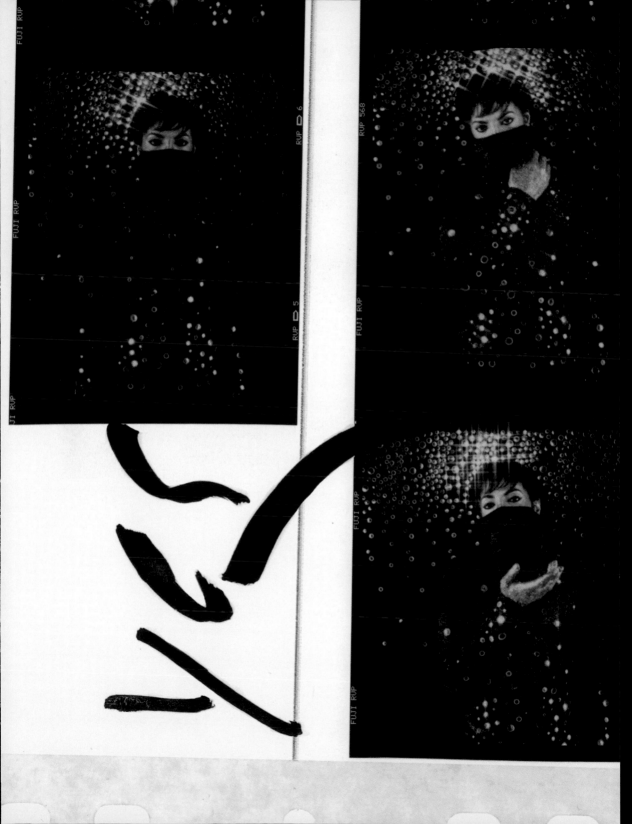

"THE MIME"

A galactic voyager, Michael dances in a starry cloud like a child. "Don't let's ask for the moon," he seems to say. "We have the stars."

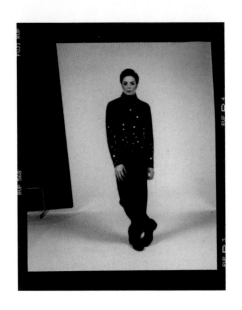

56

ARNO BANI (b. 1976)

Michael Jackson "The Mime" n°1, 1999

Unique print, 2010.

Lambda silver print.

Signed, dated, and numbered 1/1.

Print: 9.7 cm x 7.8 cm

Image: 8.7 cm x 6.8 cm

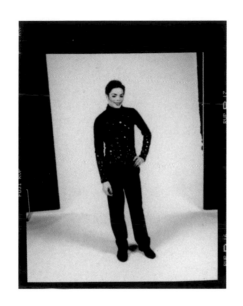

57

ARNO BANI (b. 1976)

Michael Jackson "The Mime" n°2, 1999

Unique print, 2010.

Lambda silver print.

Signed, dated, and numbered 1/1.

Print: 9.7 cm x 7.8 cm

Image: 8.7 cm x 6.8 cm

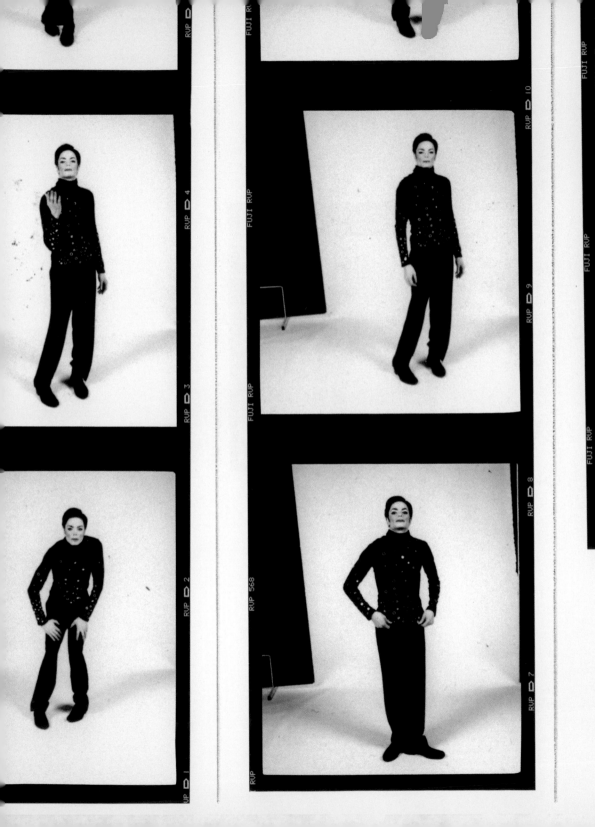

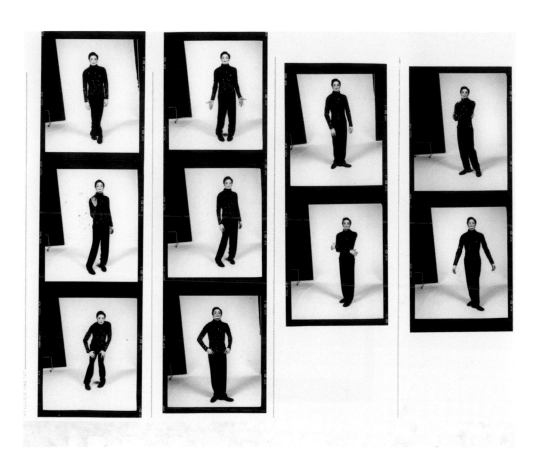

58

ARNO BANI (b. 1976)

Michael Jackson "The Mime," 1999

Contact sheet n°29. Unique print, 1999.

Contact sheet with ten images.

Color print on Fujicolor paper.

Signed, dated, and numbered 1/1.

25 cm x 29.7 cm

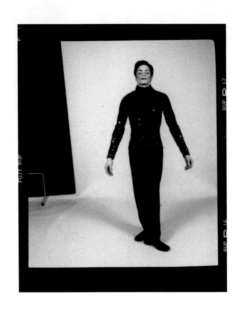

59

ARNO BANI (b. 1976)

Michael Jackson "The Mime" n°3, 1999

Unique print, 2010.

Lambda silver print.

Signed, dated, and numbered 1/1.

Print: 9.7 cm x 7.8 cm

Image: 8.7 cm x 6.8 cm

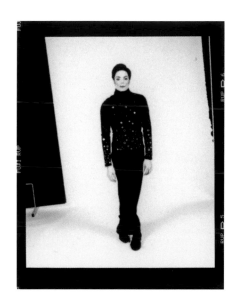

60

ARNO BANI (b. 1976)

Michael Jackson "The Mime" n°4, 1999

Unique print, 2010.

Lambda silver print.

Signed, dated, and numbered 1/1.

Print: 9.7 cm x 7.8 cm

Image: 8.7 cm x 6.8 cm

A dance icon and his moonwalk.
Michael Jackson, the ultimate artist.

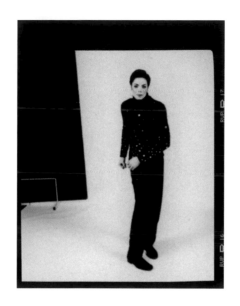

61

ARNO BANI (b. 1976)

Michael Jackson "The Mime" n°5, 1999

Unique print, 2010.

Lambda silver print.

Signed, dated, and numbered 1/1.

Print: 9.7 cm x 7.8 cm

Image: 8.7 cm x 6.8 cm

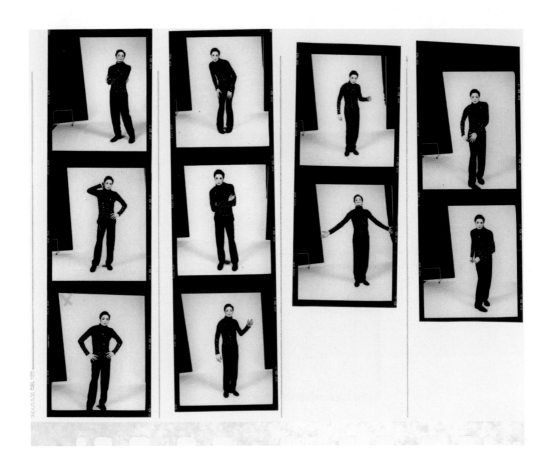

62

ARNO BANI (b. 1976)

Michael Jackson "The Mime," 1999

Contact sheet n°26. Unique print, 1999.

Contact sheet with ten images including one selected.

Color print on Fujicolor paper.

Signed, dated, and numbered 1/1.

25 cm x 29.7 cm

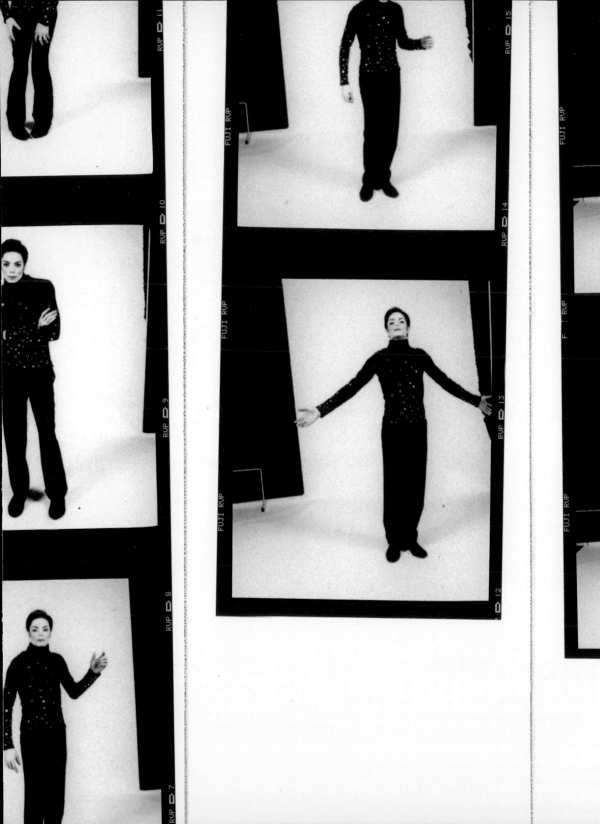

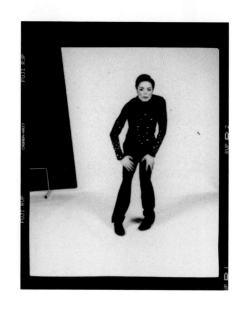

63

ARNO BANI (b. 1976)

Michael Jackson "The Mime" n°6, 1999

Unique print, 2010.

Lambda silver print.

Signed, dated, and numbered 1/1.

Print: 9.7 cm x 7.8 cm

Image: 8.7 cm x 6.8 cm

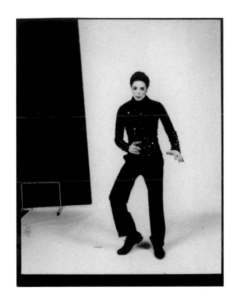

64

ARNO BANI (b. 1976)

Michael Jackson "The Mime" n°7, 1999
Unique print, 2010.
Lambda silver print.
Signed, dated, and numbered 1/1.
Print: 9.7 cm x 7.8 cm
Image: 8.7 cm x 6.8 cm

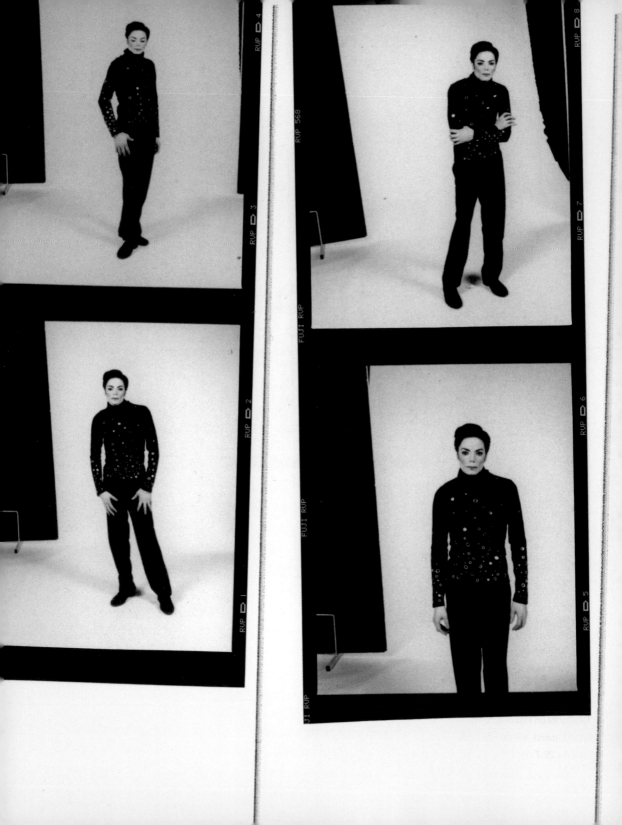

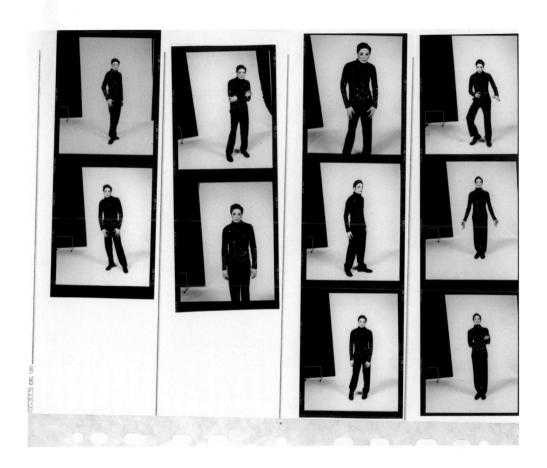

65

ARNO BANI (b. 1976)

Michael Jackson "The Mime," 1999

Contact sheet n°28. Unique print, 1999.

Contact sheet with ten images.

Color print on Fujicolor paper.

Signed, dated, and numbered 1/1.

25 cm x 29.7 cm

"I'm not like other guys."
Michael Jackson, *Thriller*

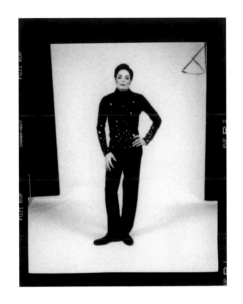

66

ARNO BANI (b. 1976)

Michael Jackson "The Mime" n°8, 1999

Unique print, 2010.

Lambda silver print.

Signed, dated, and numbered 1/1.

Print: 9.7 cm x 7.8 cm

Image: 8.7 cm x 6.8 cm

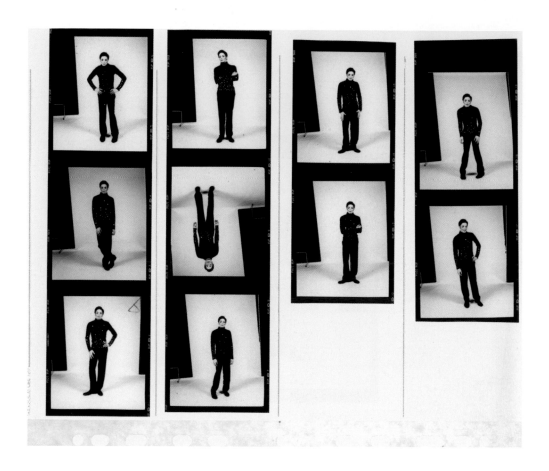

67

ARNO BANI (b. 1976)

Michael Jackson "The Mime," 1999

Contact sheet n°31. Unique print, 1999.

Contact sheet with ten images including one selected.

Color print on Fujicolor paper.

Signed, dated, and numbered 1/1.

25 cm x 29.7 cm

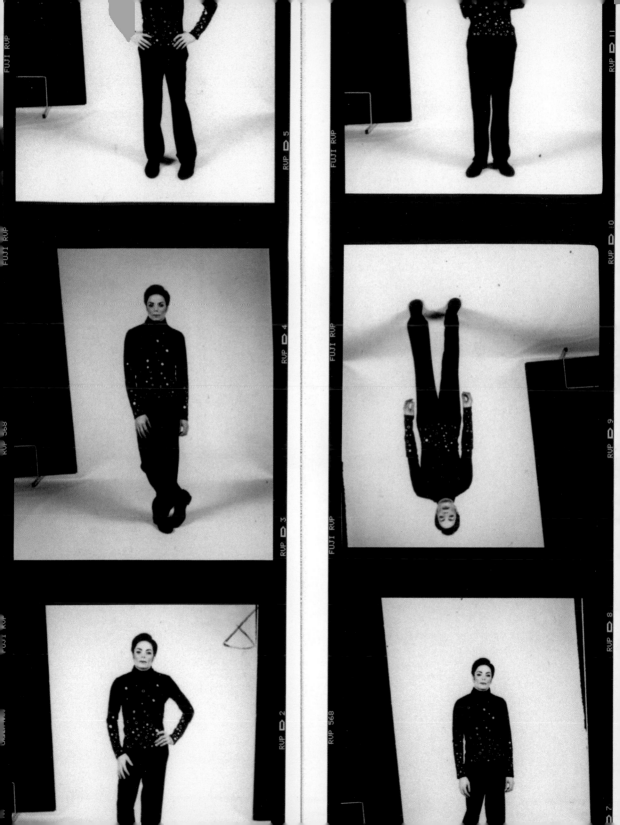

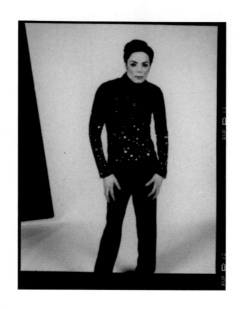

68

ARNO BANI (b. 1976)

Michael Jackson "The Mime" n°9, 1999

Unique print, 2010.

Lambda silver print.

Signed, dated, and numbered 1/1.

Print: 9.7 cm x 7.8 cm

Image: 8.7 cm x 6.8 cm

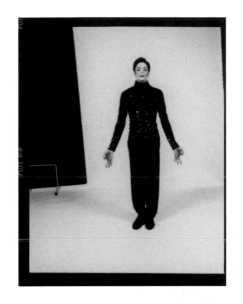

69
ARNO BANI (b. 1976)

Michael Jackson "The Mime" n°10, 1999

Unique print, 2010.

Lambda silver print.

Signed, dated, and numbered 1/1.

Print: 9.7 cm x 7.8 cm

Image: 8.7 cm x 6.8 cm

"BLACK OR WHITE"

Innocent rather than *Bad*, Michael Jackson strolls down the Yellow Brick Road through the Land of Oz.

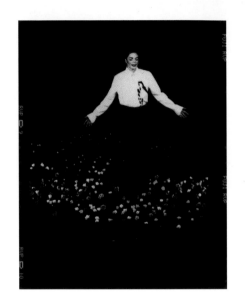

70

ARNO BANI (b. 1976)

Michael Jackson "Black or White" n°1, 1999

Unique print, 2010.

Lambda silver print.

Signed, dated, and numbered 1/1.

Print: 9.7 cm x 7.8 cm

Image: 8.7 cm x 6.8 cm

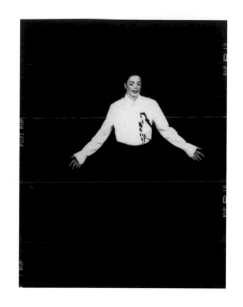

71

ARNO BANI (b. 1976)

Michael Jackson "Black or White" n°2, 1999

Unique print, 2010.

Lambda silver print.

Signed, dated, and numbered 1/1.

Print: 9.7 cm x 7.8 cm

Image: 8.7 cm x 6.8 cm

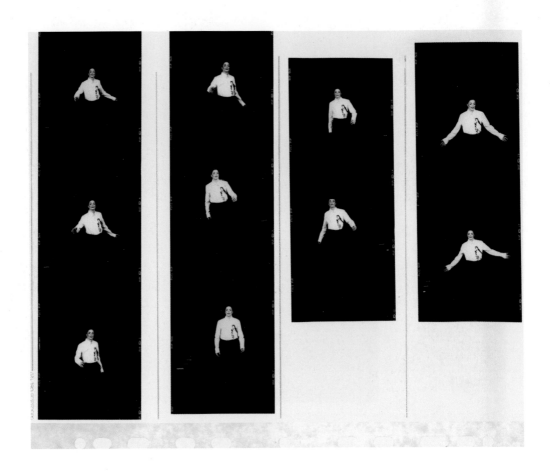

72

ARNO BANI (b. 1976)

Michael Jackson "Black or White," 1999

Contact sheet n°1. Unique print, 1999.

Contact sheet with ten images.

Color print on Fujicolor paper.

Signed, dated, and numbered 1/1.

25 cm x 29.7 cm

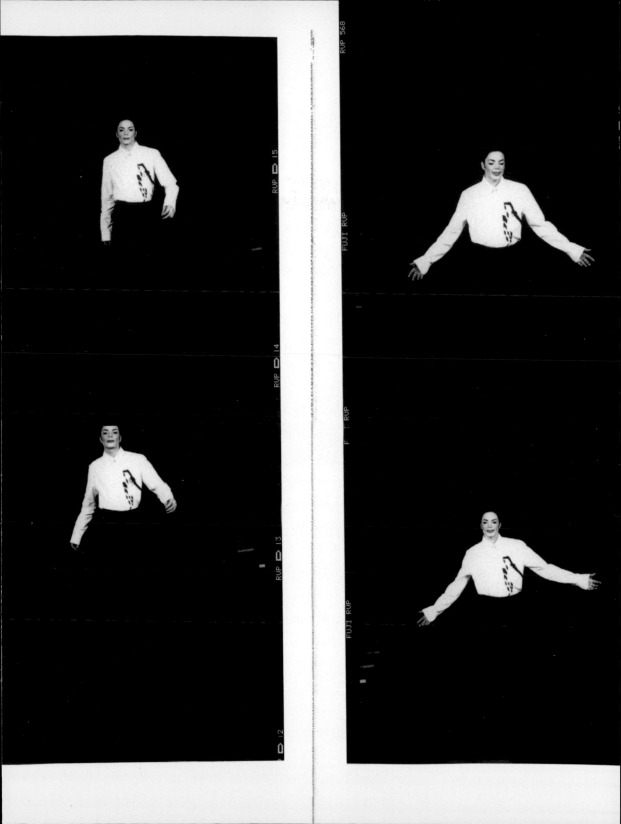

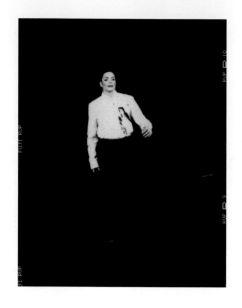

73

ARNO BANI (b. 1976)

Michael Jackson "Black or White" n°3, 1999

Unique print, 2010.

Lambda silver print.

Signed, dated, and numbered 1/1.

Print: 9.7 cm x 7.8 cm

Image: 8.7 cm x 6.8 cm

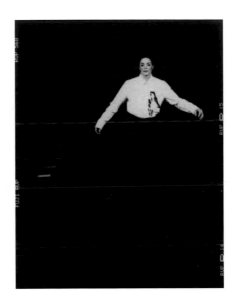

74
ARNO BANI (b. 1976)

Michael Jackson "Black or White" n°4, 1999

Unique print, 2010.

Lambda silver print.

Signed, dated, and numbered 1/1.

Print: 9.7 cm x 7.8 cm

Image: 8.7 cm x 6.8 cm

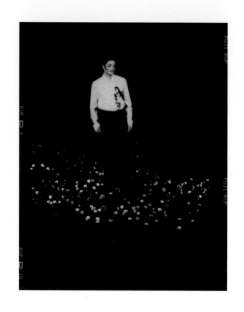

75

ARNO BANI (b. 1976)

Michael Jackson "Black or White" n°5, 1999

Unique print, 2010.

Lambda silver print.

Signed, dated, and numbered 1/1.

Print: 9.7 cm x 7.8 cm

Image: 8.7 cm x 6.8 cm

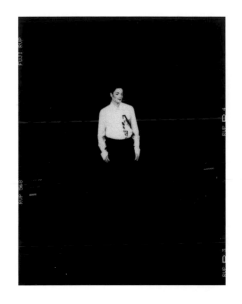

76

ARNO BANI (b. 1976)

Michael Jackson "Black or White" n°6, 1999

Unique print, 2010.

Lambda silver print.

Signed, dated, and numbered 1/1.

Print: 9.7 cm x 7.8 cm

Image. 8.7 cm x 6.8 cm

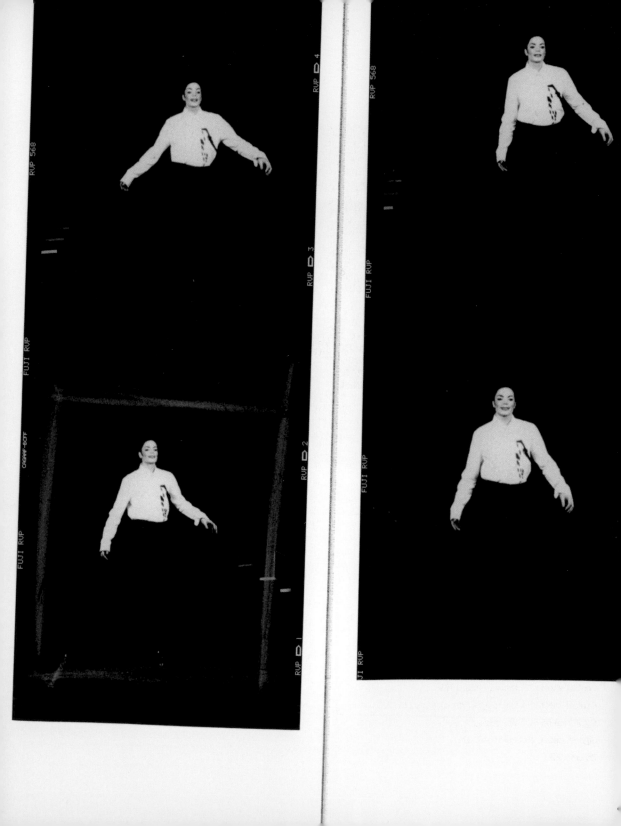

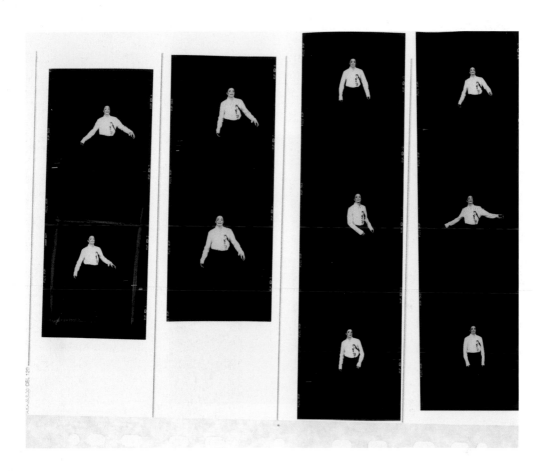

77

ARNO BANI (b. 1976)

Michael Jackson "Black or White," 1999

Contact sheet n°2. Unique print, 1999.

Contact sheet with ten images including one selected.

Color print on Fujicolor paper.

Signed, dated, and numbered 1/1.

25 cm x 29.7 cm

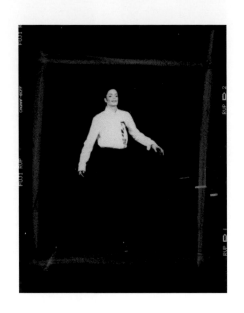

78

ARNO BANI (b. 1976)

Michael Jackson "Black or White" n°7, 1999

Unique print, 2010.

Lambda silver print.

Signed, dated, and numbered 1/1.

Print: 9.7 cm x 7.8 cm

Image: 8.7 cm x 6.8 cm

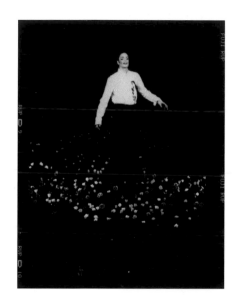

79

ARNO BANI (b. 1976)

Michael Jackson "Black or White" n°8, 1999

Unique print, 2010.

Lambda silver print.

Signed, dated, and numbered 1/1.

Print: 9.7 cm x 7.8 cm

Image: 8.7 cm x 6.8 cm

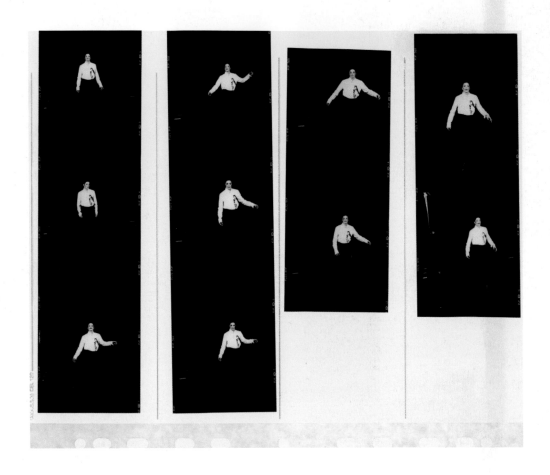

80

ARNO BANI (b. 1976)

Michael Jackson "Black or White," 1999

Contact sheet n°3. Unique print, 1999.

Contact sheet with ten images.

Color print on Fujicolor paper.

Signed, dated, and numbered 1/1.

25 cm x 29.7 cm

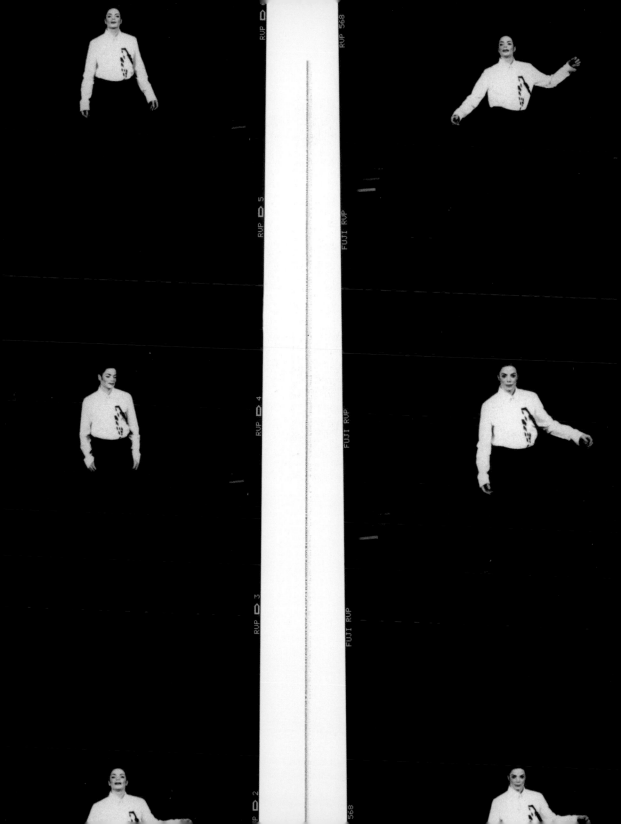

Weightless and sylphlike,
Michael seems about to
fly away like Peter Pan:
"I am youth. I am joy.
I am a little bird that just
escaped its shell."

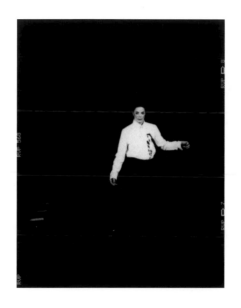

81

ARNO BANI (b. 1976)

Michael Jackson "Black or White" n°9, 1999

Unique print, 2010.

Lambda silver print.

Signed, dated, and numbered 1/1.

Print: 9.7 cm x 7.8 cm

Image: 8.7 cm x 6.8 cm

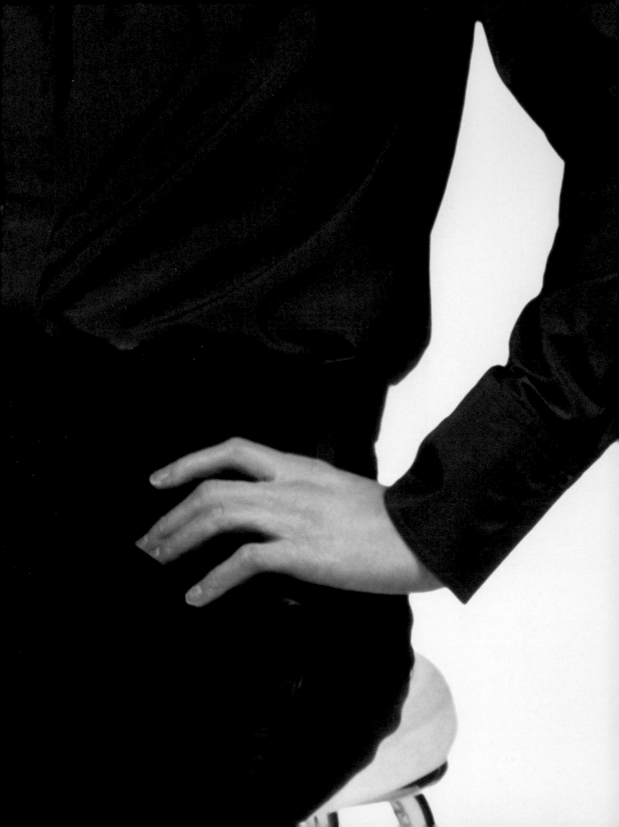

IN THE STUDIO

HIStory: Past, Present and Future.
Forever Michael by Arno Bani.

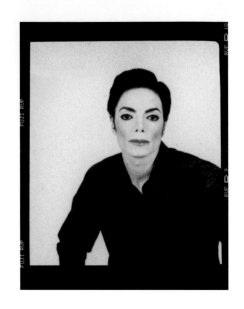

82

ARNO BANI (b. 1976)

Michael Jackson in the Studio n°1, 1999

Unique print, 2010.

Lambda silver print.

Signed, dated, and numbered 1/1.

Print: 9.7 cm x 7.8 cm

Image: 8.7 cm x 6.8 cm

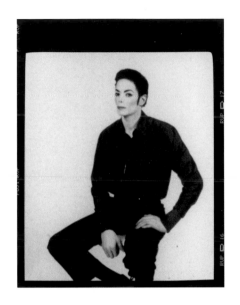

83

ARNO BANI (b. 1976)

Michael Jackson in the Studio n°2, 1999

Unique print, 2010.

Lambda silver print.

Signed, dated, and numbered 1/1.

Print: 9.7 cm x 7.8 cm

Image: 8.7 cm x 6.8 cm

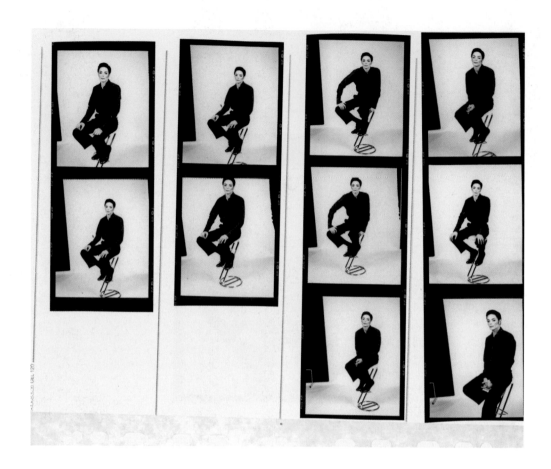

84

ARNO BANI (b. 1976)

Michael Jackson in the Studio, 1999

Contact sheet n°27. Unique print, 1999.

Contact sheet with ten images.

Color print on Fujicolor paper.

Signed, dated, and numbered 1/1.

25 cm x 29.7 cm

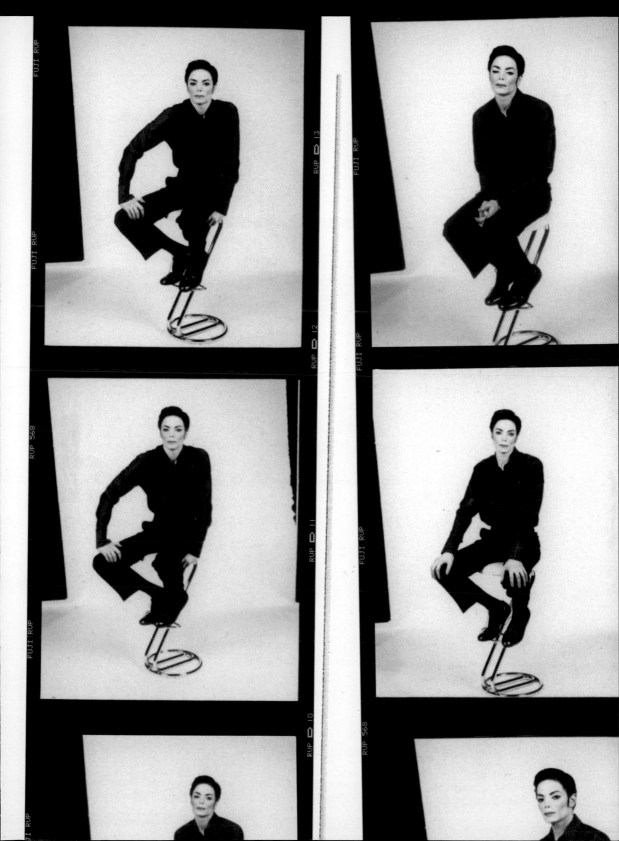

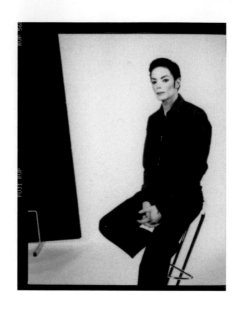

85

ARNO BANI (b. 1976)

Michael Jackson in the Studio n°3, 1999

Unique print, 2010.

Lambda silver print.

Signed, dated, and numbered 1/1.

Print: 9.7 cm x 7.8 cm

Image: 8.7 cm x 6.8 cm

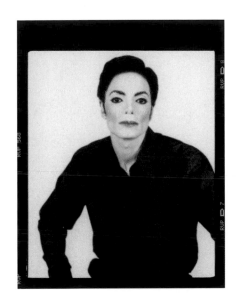

86

ARNO BANI (b. 1976)

Michael Jackson in the Studio n°4, 1999

Unique print, 2010.

Lambda silver print.

Signed, dated, and numbered 1/1.

Print: 9.7 cm x 7.8 cm

Image: 8.7 cm x 6.8 cm

"Success, fame and fortune,
they're all illusions.
All there is that is real
is the friendship that two
can share," said Michael
as the Scarecrow
in *The Wiz.*

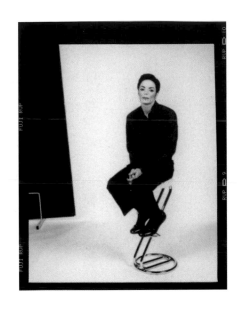

87
ARNO BANI (b. 1976)

Michael Jackson in the Studio n°5, 1999

Unique print, 2010.

Lambda silver print.

Signed, dated, and numbered 1/1.

Print: 9.7 cm x 7.8 cm

Image: 8.7 cm x 6.8 cm

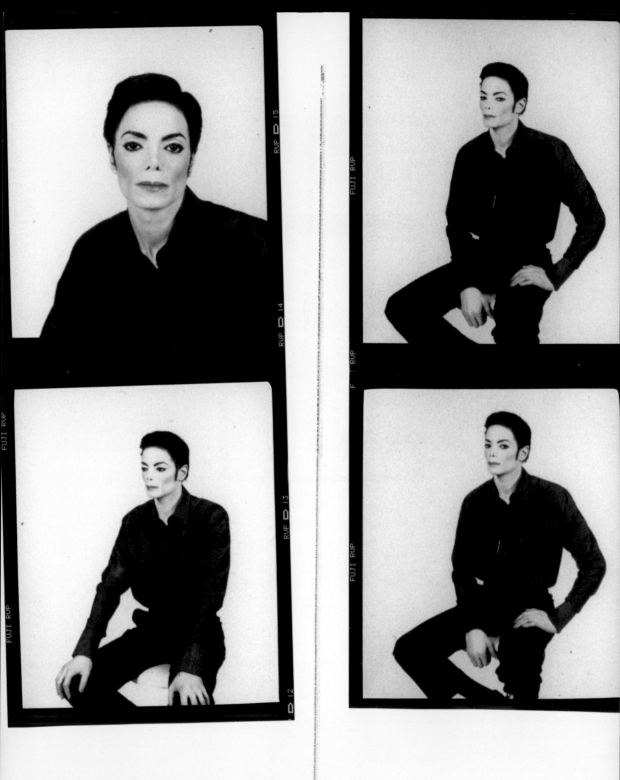

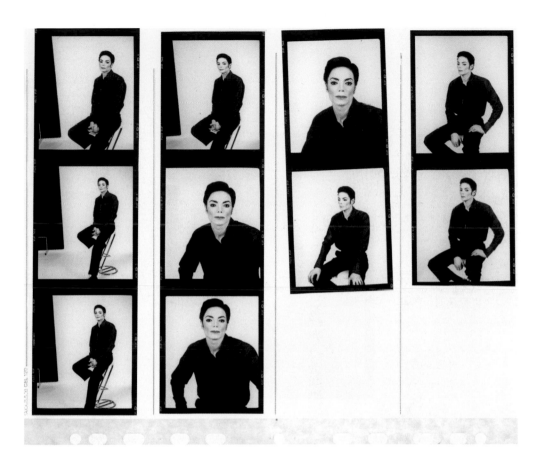

88

ARNO BANI (b. 1976)

Michael Jackson in the Studio, 1999

Contact sheet n°30. Unique print, 1999.

Contact sheet with ten images.

Color print on Fujicolor paper.

Signed, dated, and numbered 1/1.

25 cm x 29.7 cm

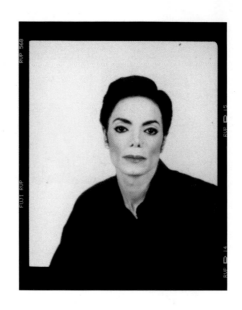

89

ARNO BANI (b. 1976)

Michael Jackson in the Studio n°6, 1999

Unique print, 2010.

Lambda silver print.

Signed, dated, and numbered 1/1.

Print: 9.7 cm x 7.8 cm

Image: 8.7 cm x 6.8 cm

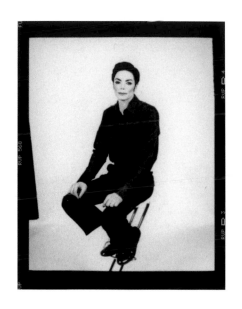

90

ARNO BANI (b. 1976)

Michael Jackson in the Studio n°7, 1999

Unique print, 2010.

Lambda silver print.

Signed, dated, and numbered 1/1.

Print: 9.7 cm x 7.8 cm

Image: 8.7 cm x 6.8 cm

Original title: *Ventes aux enchères MICHAEL JACKSON par Arno Bani*

Text: Jéromine Savignon
Translated from French by Kerrin Rousset
Photographs: Arno Bani
Managing Director: Fabienne Kriegel
Editor: Nathalie Lefebvre
Production: Nathalie Lautout and Amandine Sevestre
Layout: Vincent Lanceau
Editorial Director: Frédéric Chambre
Art Director: Aurore Blot Lefevre

First published in France in 2010 by Éditions du Chêne-Hachette Livre and Pierre Bergé & associés

First published in the United Kingdom in 2010 by
Thames & Hudson Ltd, 181A High Holborn,
London WC1V 7QX

British Library Cataloguing-in-Publication Data
A catalogue record for this book is available from the British Library

ISBN: 978-0-500-28925-9

Printed and bound in Spain

To find out about all our publications, please visit **www.thamesandhudson.com**.
There you can subscribe to our e-newsletter, browse or download
our current catalogue, and buy any titles that are in print.

Acknowledgments by Arno Bani

I dedicate this catalog to my son Léon, to my parents, to Laurence, to Alma, to my uncle, to Velvet, to Marmotte, to my family, to my friends, to Ari.

I would like to thank:
Michael Jackson

Emmanuel Asmar, Frédéric Chambre, Jéromine Savignon, Jérôme Dreyfuss, Topolino, Seb Bascle, Maïda Gregory-Boina, Frédérique Lorca, François Lesage, Daniel Adric, Gilles Quemoun, Isabella Blow, Marco Giani, Ora-ïto, Christophe Pete, Pierre-Henri Camy, Jérôme Coste, Isabelle Baud, Thierry Marotte, Martine Lagier, Pauline Étienne, La C2C, Anne-Claire Albecker.

Acknowledgments by Jéromine Savignon

I would like to express all my gratitude to Pierre Bergé.

I would also like to thank Arno Bani, Frédéric Chambre, Emmanuel Asmar, Pierre Huyghe, all of Arno's team for the Michael Jackson photo shoot, Goran Vejvoda for his talents as a visual artist and composer, Xavier Landrit for his kind and precious help, Charlotte Beauvisage, Jean-Philippe de Tonnac, François Lesage, France de Malval, Emmanuel de Rengervé, Gaël Mamine, Véronique Belloir, Vincent Mermier, Bernard Savignon, Mage Barbier, and the documentation center at the Galliera Museum.

I dedicate my account of Michael and Arno's beautiful story to my son, Ludwig.

Acknowledgments by Frédéric Chambre and Antoine Godeau

We would like to thank:
Emmanuel Asmar, Arno Bani, Charlotte Beauvisage, Pierre Leroy, Fabienne Kriegel, Nathalie Lefebvre, Sherri Aldis, Jéromine Savignon, Aurore Blot Lefevre, and the entire team at Pierre Bergé & associés, Patricia Goldman Communication, Serum&co, Montana&co.

CONDITIONS OF SALE

The auction will be conducted in euros (€) and lots will be paid full in cash. As well as the hammer price, buyers will pay the following premium: up to €500,000, 24% inclusive of tax (20.07% HT + 19.6% VAT), and above €500,000, 17.94% inclusive of tax (15% HT + 19.6% VAT). This calculation applies to each lot individually.

GUARANTEES

The auctioneer is bound by the indications in the catalogue, modified only by eventual announcements made at the time of the sale noted into the legal records thereof. An exhibition prior to the sale permits buyers to establish the condition of the works offered for sale and therefore no claims will be accepted after the hammer has fallen. Catalogue photographs are not contractually binding. Antique objects generally have wear and have been restored; we have brought attention to these as much as possible. Their conditions are mentioned in the catalogue strictly for your information.

DESCRIPTION OF LOTS AND REPORT CONDITION

Lots will be sold in condition. The potential buyer must ensure by himself the condition of each lot and the nature and extent of any damage or restoration before considering the sale. The exhibition prior to the auction is open to everyone and is not subject to any entrance fee. The Pierre Bergé specialists are available to potential bidders and the public to provide any information or advice if needed. They can also establish, on demand, written or verbal reports about the conservation state of the objects. The written reports on the condition of the objects are available on demand for the lots with greater value than 3,000 euros. All references included on catalogue description or condition reports, any oral or written statement made otherwise constitute an expression of a mere opinion and not fact. Because of their age and their nature, many lots are not in their original condition and some descriptions in the catalogue or in the condition report may, in some cases, mention damages and/or restoration. References in the catalogue description, or in the condition report, on an accident or a restoration are made to facilitate the inspection by potential bidders and are subject to the assessment that must be the result of a personal examination by the buyer or his appropriate representative. The absence of such a reference in the catalogue does not imply that an object is free of any defects or restoration; furthermore a reference to a particular defect does not imply absence of all other defects. Information on the dimensions of a lot shown in the catalogue description or in the condition report is intended as information only and is not guaranteed. Estimated selling price should not be considered as implying the certainty that the object will be sold for the estimated price or that the value given here is a guaranteed value.

BIDS

Bidding will be in accordance with the lot numbers listed in the catalogue or as announced by Pierre Bergé & associés, and will be in increments determined by the auctioneer. The highest and last bidder will be the purchaser. Should Pierre Bergé & associés recognize two simultaneous bids on an object, the lot will be put up for sale again and all those present in the sale room may participate in this second opportunity to bid.

ABSENTEE BIDS AND TELEPHONE BIDS

Those wishing to make a bid in writing or by telephone should use the form provided with the auction catalogue. This form, accompanied by the bidder's bank details, must be received by PBA no later than two days before the sale. Telephone bids are a free service designed for clients who are unable to be present at auction. Pierre Bergé & associés cannot be held responsible for any problems due to technical difficulties.

REMOVAL OF PURCHASES

From the moment the hammer falls, sold items will be in the exclusive responsibility of the buyer. If payment is made by check or by wire transfer, the objects can only be delivered once the full amount has been received in our account, the buyer becoming the owner only at this moment. From the moment the hammer falls, sold items will be in the exclusive responsibility of the buyer. Transportation and storage will be invalided to the buyer. The buyer will be solely responsible for insurance, and Pierre Bergé & associés assume no viability for any damage items may incur from the time the hammer falls. All transportation arrangements are the sole responsibility of the buyer.

PREEMPTION

In certain cases, the French State is entitled to use its right of preemption on works of art or private documents, as stated in the clauses of Article 37 in the law of December 31, 1921, modified by Article 59 in the law of July 10, 2000. This means that the state substitutes itself for the last bidder and becomes the buyer. In such a case, a representative of the French State announces the exercise of the preemption right during the auction and immediately after the lot has been sold, and this declaration will be recorded in the official sale record. The French State will have then fifteen (15) days to confirm the preemption decision. Pierre Bergé & associés will not be held responsible for any administrative decisions of the French State regarding the use of its right of preemption.

DEFAULT OF THE BUYER

Any lot unpaid by the buyer within 3 months since the day of the auction will be re-ordered for sale by Pierre Bergé & associés, after the legal former notice, the possible difference of price remaining to the buyer in default. As a result, the owner mandates PBA to decide and carry out the procedure legally applied in the case of default of the buyer.

PIERRE
BERGÉ
& ASSOCIÉS

ANTOINE GODEAU - FRÉDÉRIC CHAMBRE

BID FORM

☐ ABSENTEE BID ☐ PHONE CALL REQUEST

Name

Auction Location Address
HÔTEL SALOMON DE ROTHSCHILD

Phone
Monday, December 13, 2010

Fax
Michael Jackson by Arno Bani

E-mail

I have read the conditions of sale and the guide to buyers printed in this catalogue and agree to abide by them. I grant you permission to purchase on my behalf items within the limits indicated in euros. (These limits do not include buyer's premium and taxes.)

Required bank references (Please complete and join following page)

Commercial references in Paris or London

Please note that only commission bids in writing will be accepted for lots estimated under € 800. Telephone bids will not be registered for these lots.

LOT No	LOT DESCRIPTION	TOP LIMIT OF BID IN EUROS

To allow time for processing, absentee bids should be received at least 24 hours before the sale begins.

Required signature: Date:

Send to:
PIERRE BERGÉ & ASSOCIÉS
12, rue Drouot _ 7 5009 Paris www.pba-auctions.com
T. +33 (0)1 49 49 90 00 **F.** +33 (0)1 49 49 90 01

P.T.O.

PIERRE BERGÉ & ASSOCIÉS

ANTOINE GODEAU - FRÉDÉRIC CHAMBRE

PLEASE NOTE THAT YOU WILL NOT ABLE TO BID UNLESS YOU HAVE COMPLETED THIS FORM IN ADVANCE.

Sale date MONDAY, DECEMBER 13, 2010

Full name

Address

Agent ☐ Yes ☐ No

IDENTIFICATION PAPER - PASSPORT COPY

Phone number

Bank

Person to contact

Account number Phone

References in art market

FOR ANY INFORMATION PLEASE CALL SYLVIE GONNIN +33 (0)1 49 49 90 25 sgonnin@pba-auctions.com

I agree that I will bid subject to the conditions of sale printed in the catalogue for this sale.

Required signature: Date:

Société de Ventes Volontaires
Agrément n2002-128
12, rue Drouot _ 75009 Paris
T. +33 (0)1 49 49 90 00 **F.** +33 (0)1 49 49 90 01 www.pba-auctions.com
S.A.S. au capital de 600.000 euros **NSIRET** 441 709 961 00029 **TVA INTRACOM** FR 91 441 709 961 000 29